here and now is all we got

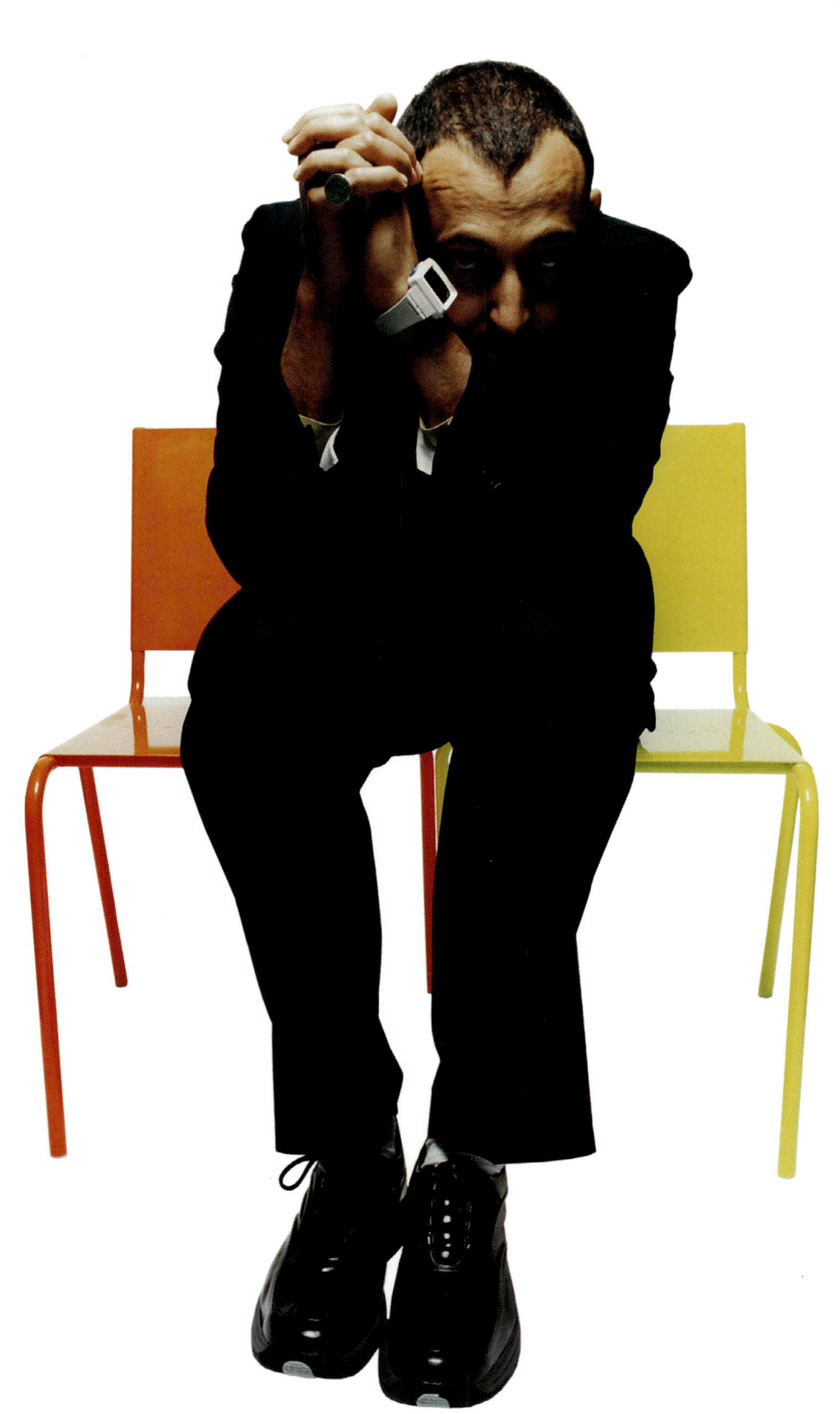

karim rashid
I want to change the world

Thames & Hudson

concept for lipstick, Maybelline, USA, 2000

Although I design objects, the experience is more critical than the objects themselves. Instead of filling the ground or a capsule with objects, I proposed to design an actual capsulelike object and not the contents. The Digitalia capsule is a universal container that represents all our objects in an abstract form. The contents are immaterial and were listed on a digital scrolling display. The capsule thus became a metaphor for the cosmos of possibilities in containment.

As an industrial designer and artist I am interested in our built environment, and the container is a critical signifier of our time. In Digitalia names of objects, products, things, memorabilia, achievements, current events, movements, etc., scroll on two-inch red LED's. The object is like a future being and the LED scrolls represent the documentation of our time. I concentrated on what I call the digital age, the information age, or the third Industrial Revolution (roughly thirty years). In order to document the occurrences of this age I tabulated two thousand English words (although most of these words are universal).

The form of Digitalia is a capsule, with its symbolic shape of ever-changing dynamic parabolic cosmos of our digital world in which we live today. It is an abstract form that connotes large chrome nuclei, implying the coming together of the cosmos and the shrinking of the world due to the rapid nature of communications and media. The object speaks of information, electronics, myths, markets, tribes, fetishes, dreams, desires, possessions, synthetics, of our evanescent public memory. We do not need many things in the future. This singular object as a capsule represents the fact that the objects we do have in the future must have meaning and memory—fewer but better objects so that we can strive to create a cosmic sense of well-being as the next millennium nears.

digitalia time capsule, produced by Nambé, 1999, and exhibited at The Heckscher Museum of Art, 2000

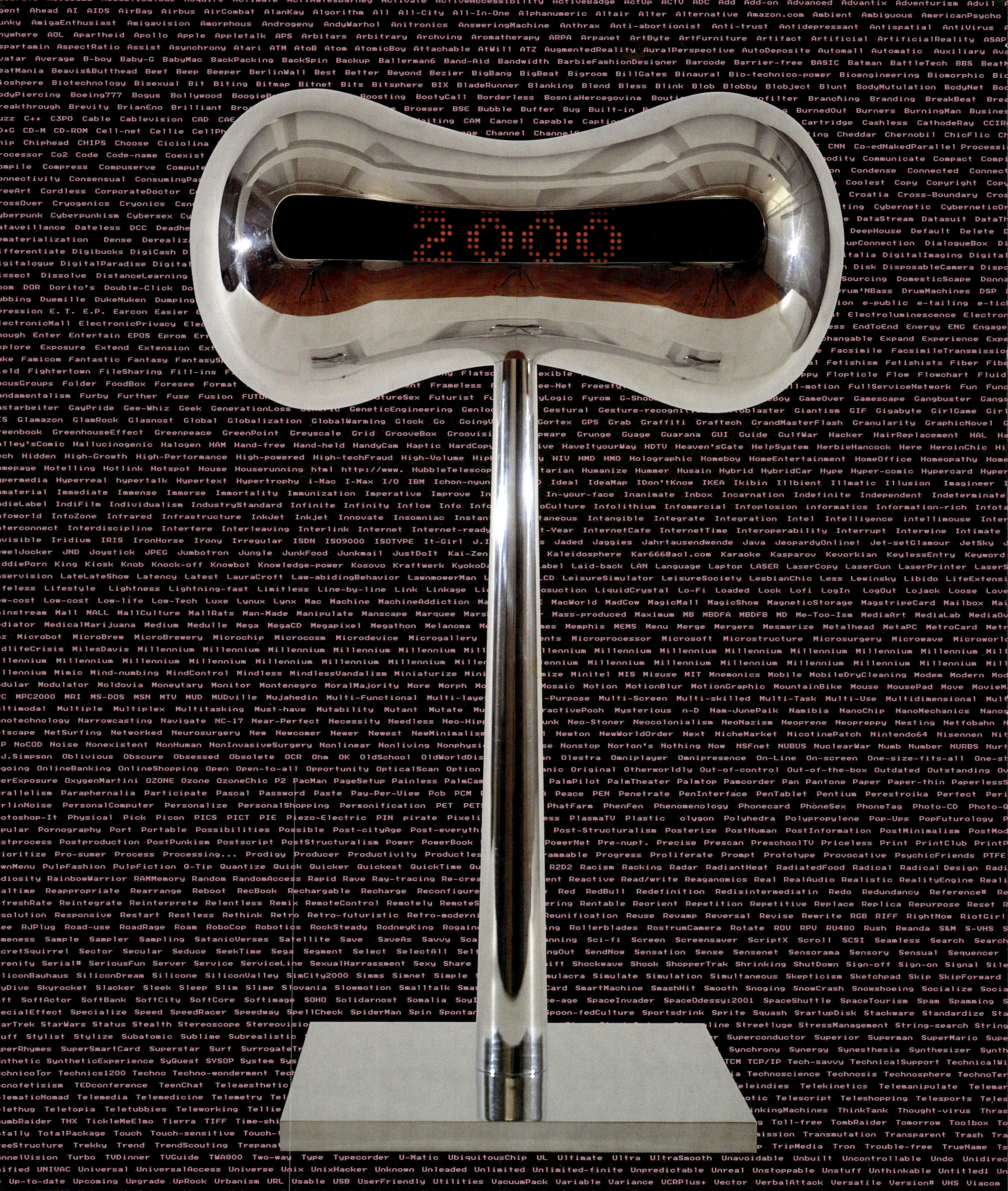

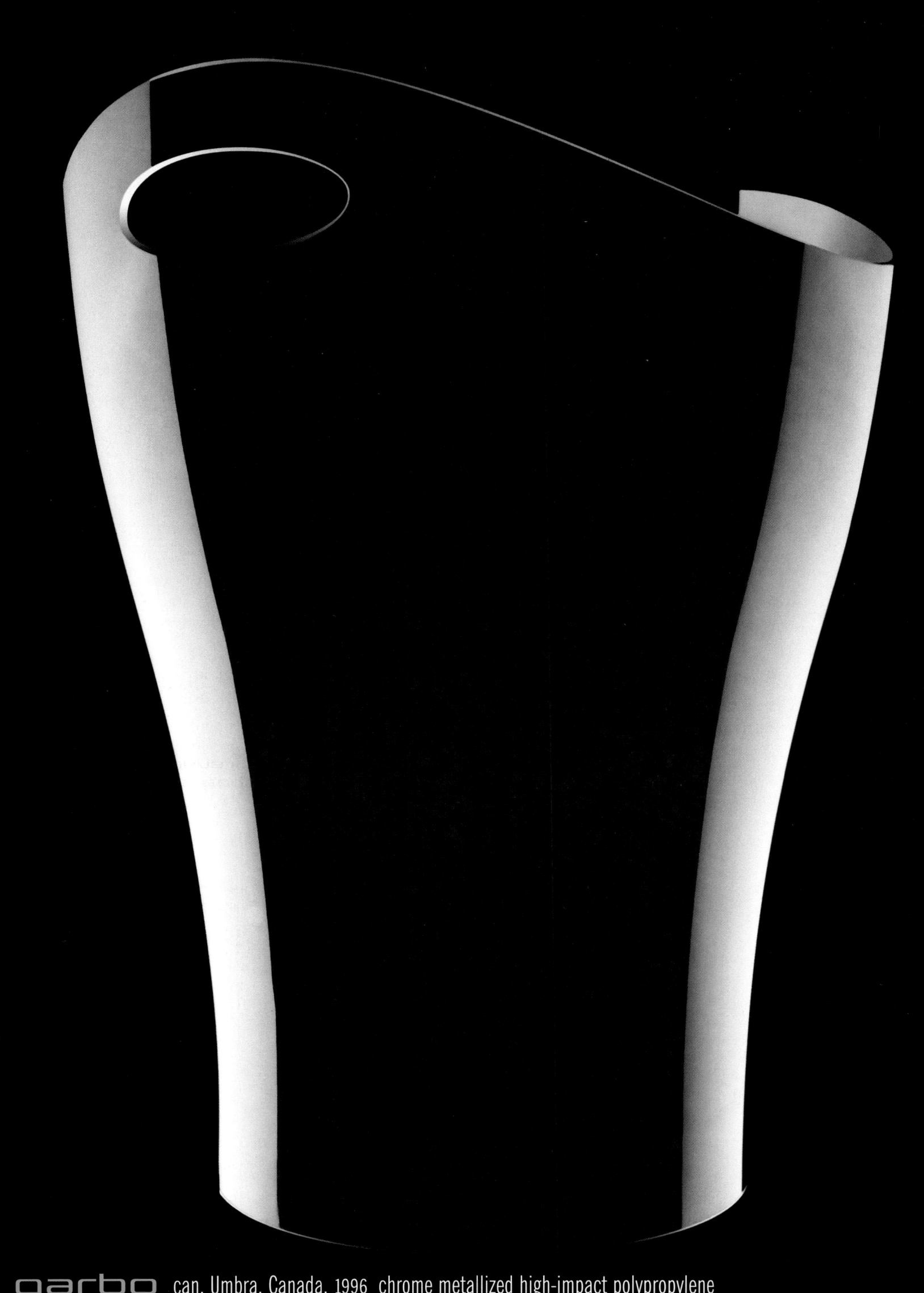

garbo can, Umbra, Canada, 1996 chrome metallized high-impact polypropylene

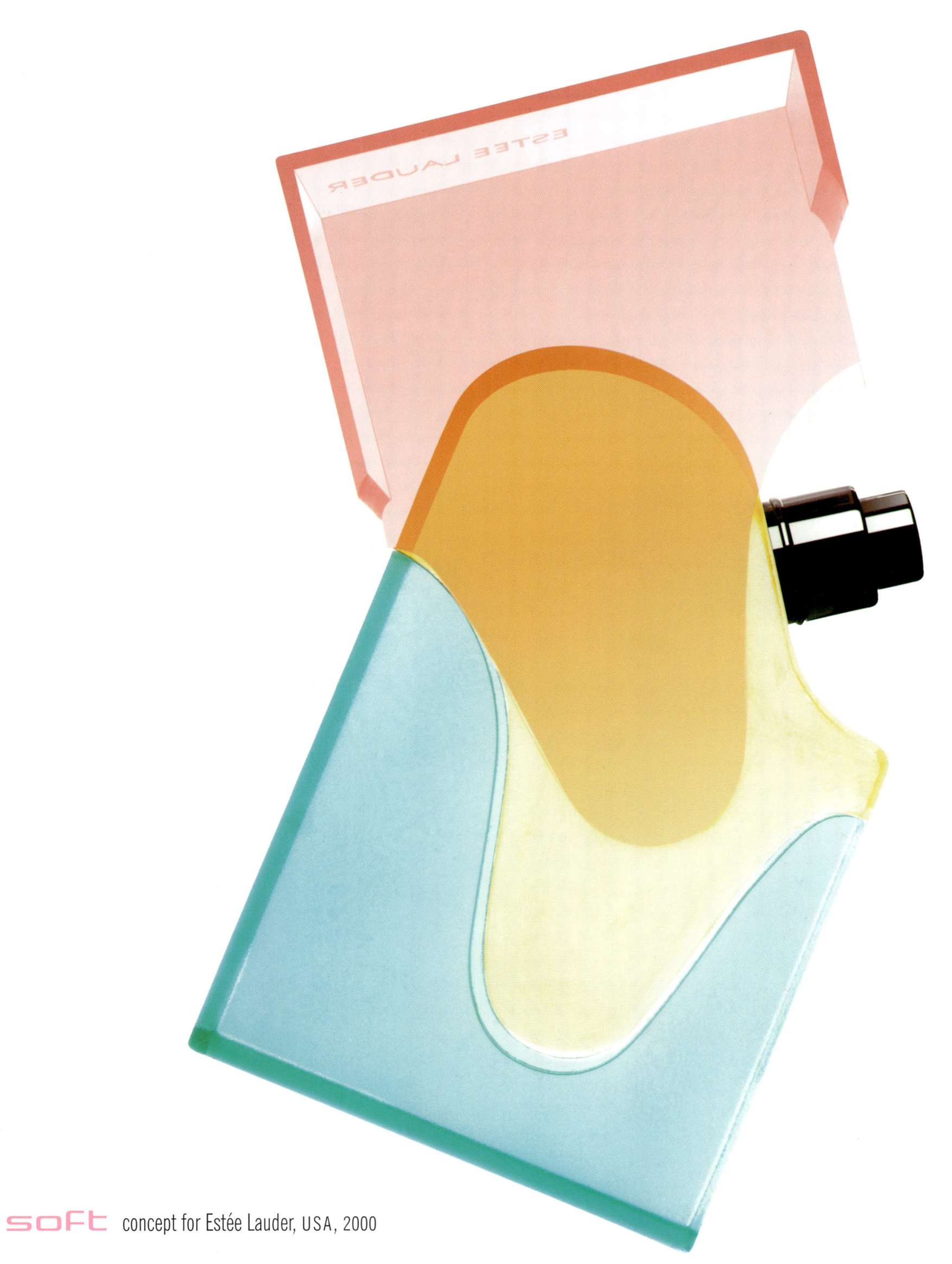

soft concept for Estée Lauder, USA, 2000

surfacescape Edra, Italy, 2001 four reconfigurable sections

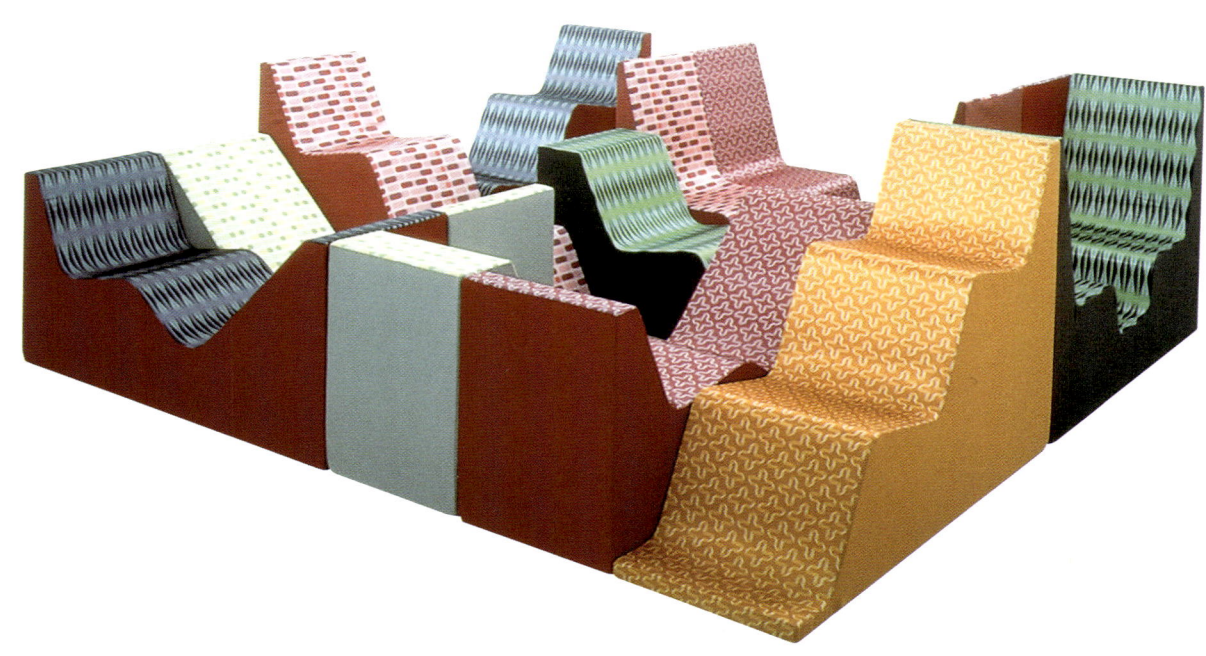

I have a vivid recollection of my first encounter with Karim Rashid in New York, in May 1997, and of the enthusiasm of our editorial staff when they saw the photos of his designs, which, at the time, were still not familiar to us in Italy. Colorful, sinuous, sensual objects, but at the same time fresh, light, and new, both in their concepts and their forms, not unconcidentally realized in materials nearly extraneous to the sector of furniture and product design, and made with the most advanced industrial technologies and computer design methods. Like the Torso and Perfecto bags, designed by Karim for Issey Miyake: composed of a single sheet of shaped polypropylene, assuming a different chromatic connotation according to the way they were folded, thanks to the dual color of the bottom. Or like the seating of the Ecstasy of the Unnatural collection, with coverings in nylon and vinyl, or the viscous gel beds designed for a client in Nagoya. These are products that brought a breath of fresh air in the midst of the visual standardization of the minimalism in vogue at the time.

Looking back on these products, four years later, they seem to confirm their visionary character, their semantic capacity to sum up the symbols of a metropolitan and increasingly cosmopolitan culture, projected into the future of the digital era. For this reason it would be reductive to interpret the work of Karim Rashid in terms of organicism. In his objects—whether they are chairs, vases, lamps or bags—the use of curved, sensual lines dominates, but they are neither the organic forms of the evolved artifacts developed in the 1950s, nor those of botanical or zoological origin found in the works of many contemporary designers. If we must find a term with which to interpret this work, I would say it is "physical." Or, to put it better, it displays a natural tendency to rethink the physical-compositional conception of objects, combining the simplicity and sensuality of the sign with an utterly contemporary expression of immanence and reliability. On the other hand, the research is also oriented toward greater flexibility, both in terms of use and image, of the objects.

Let's start with the first approach, which is particularly evident, for example, in the hollow furnishings—like

gilda bojardi introduction

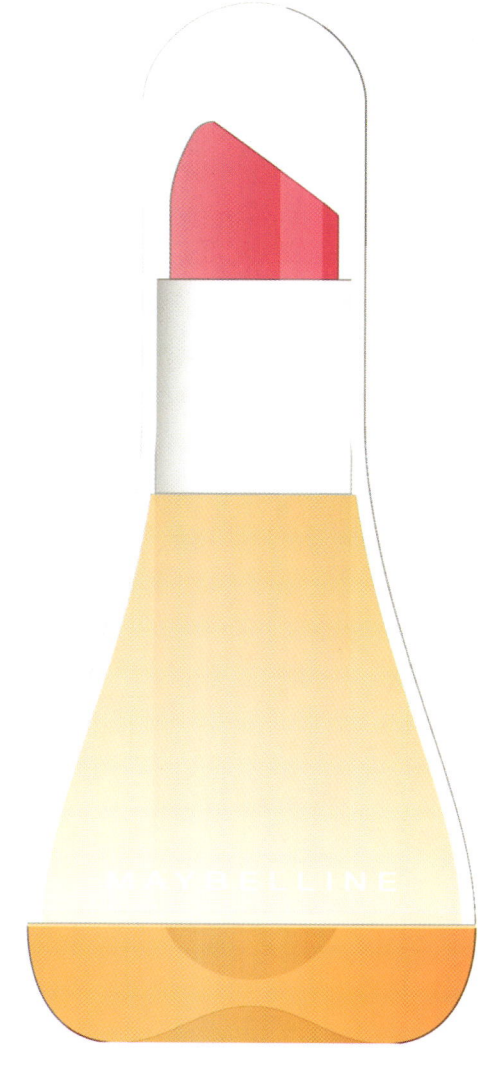

concept for lipstick, Maybelline, USA, 2000

the Floglo chairs, the Lexicon table, or the RAD16 table—but also in the multiple composition furnishings, like the Asum chairs of the Decola Vita collection. The *trait d'union* among all these products, distinguished by their extreme physical and visual lightness, is a concept of density that is perceptible rather than measurable. The objects appear in space through a strong visual weight, evident volumes, decisively characterized on the morphological plane. But their real physical mass is composed of air, by the spatial encumbrance of the wire-frame, which defines them. Therefore they are dematerialized products, but in contrast with the minimalist approach they still contain the memory of their weight, displaying a specific density: virtual, not real.

From the conceptual approach we can proceed to the strictly technological and productive approach, or that of experience. The figurative repertoire of Karim Rashid—the seductive lines, graphic symbols, almost acid colors, the desire to play with light and with the positive/negative poles—takes form thanks to research on technologies and materials. In the most highly evolved industrial production cycles he finds fertile ground for linguistic grafts: the concept of extrusion, the plastic vision of the continuum, the sense of coordination and integration of spaces. This leads to the concrete expression of the idea of the dynamic, mutant, flexible object in aesthetic, compositional and functional terms. The results include designs of vases that take on a different color to indicate when it is time to change the water for flowers, or of divans for sixteen different compositions, bookcases that become wall lamps, interlocking vases and chairs that can be arranged to form a mutable domestic landscape. These are almost futuristic objects, on which Rashid continues working in a prolific way, never losing sight of the needs of the consumer, the true final aim of all his designs.

industrial martini glass, Bombay Sapphire, USA, 2000

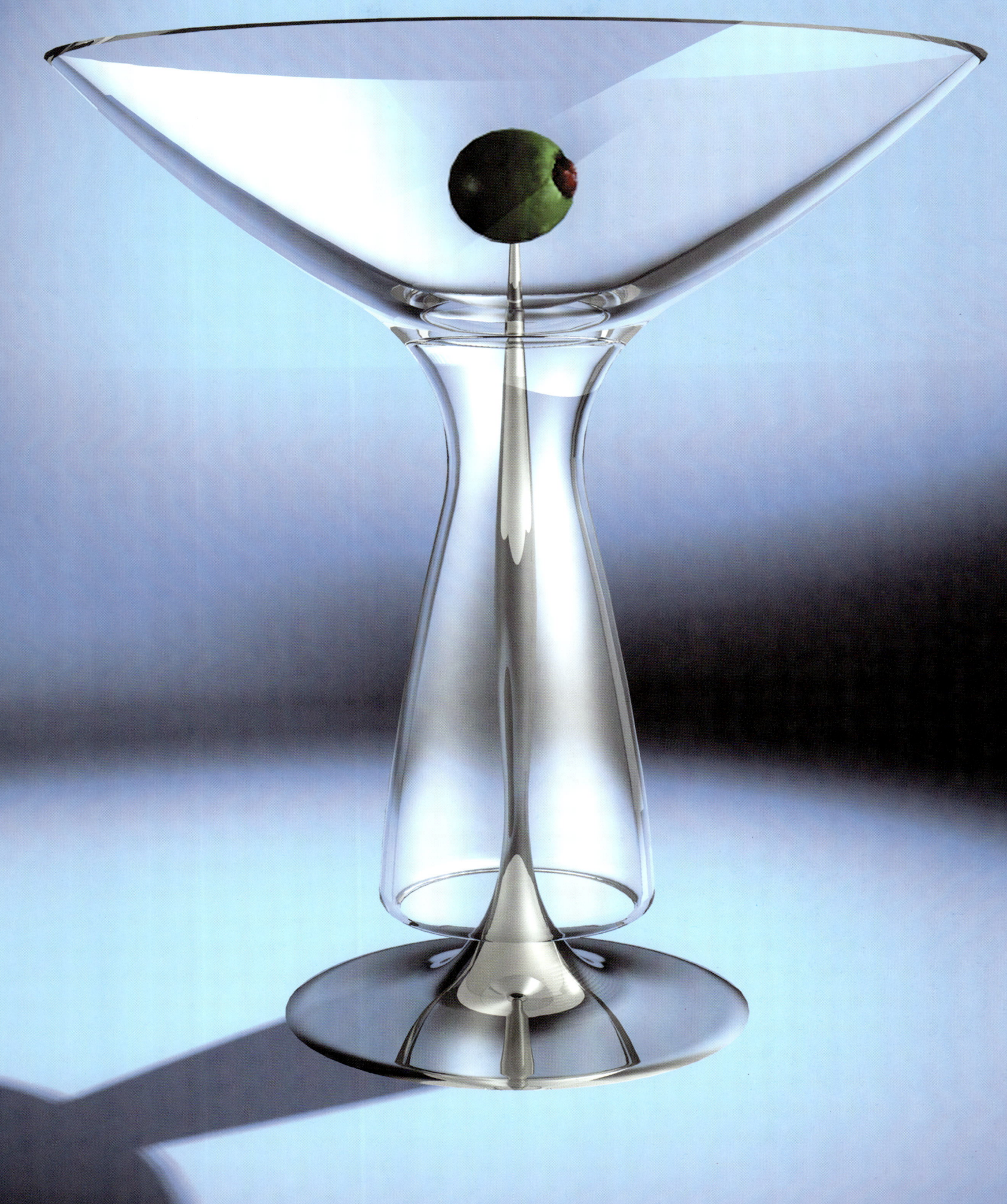

Work is life.

>> Only the subject desires, only the object seduces. Jean Baudrillard

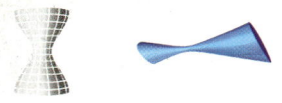

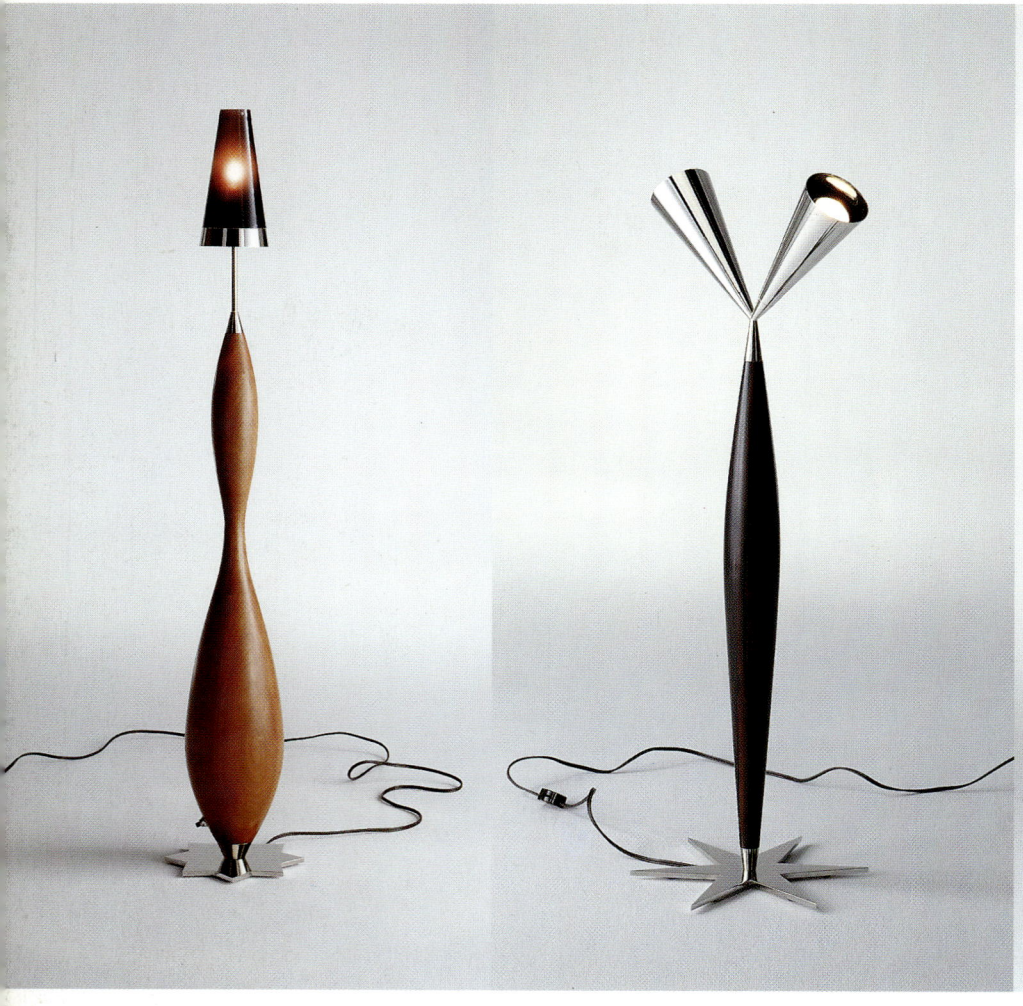

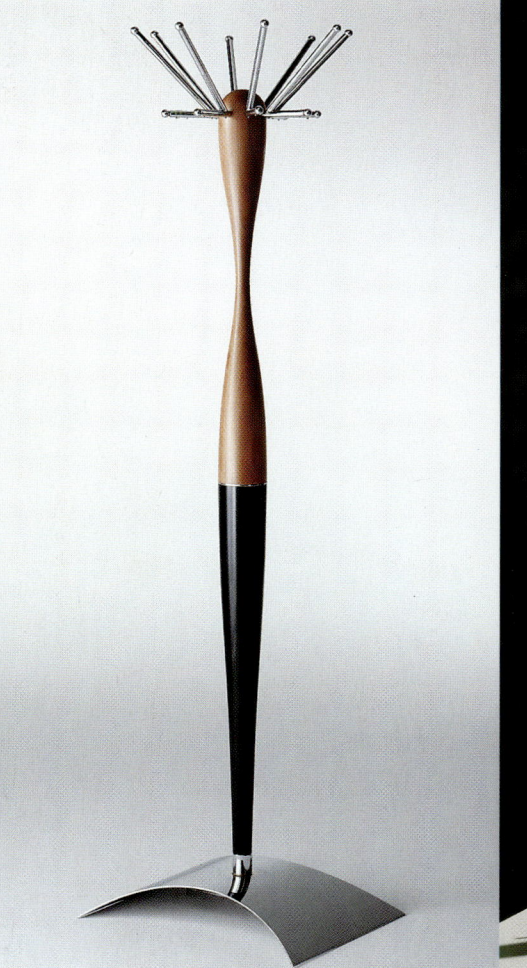

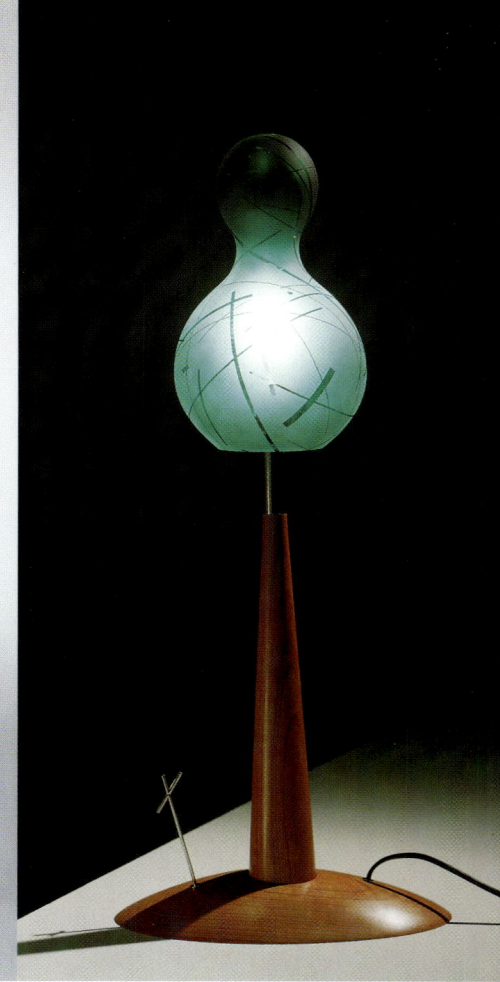

farrago
lamp, 1989

cherry wood, nickel-plated steel, and black glass

hyperborean
lamp, 1989

macasser ebony wood, nickel-plated brass, and steel; three settings

cotquean
coat rack, 1989

chrome, steel, and wood; collapsible, limited production by designer

orb
lamp, 1990

rosewood base, green blown glass, with frosted projected drawing; nickel cross is touch-sensitive switch

inset on next page:

chora
lamp, 1989

walnut, blond birch, aluminum, and blown glass; touch-sensitive aluminum switch

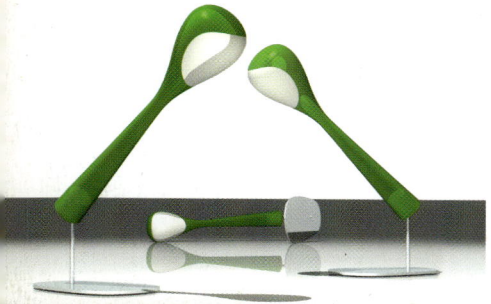

lobject concept for lamp, FLOS, 2001

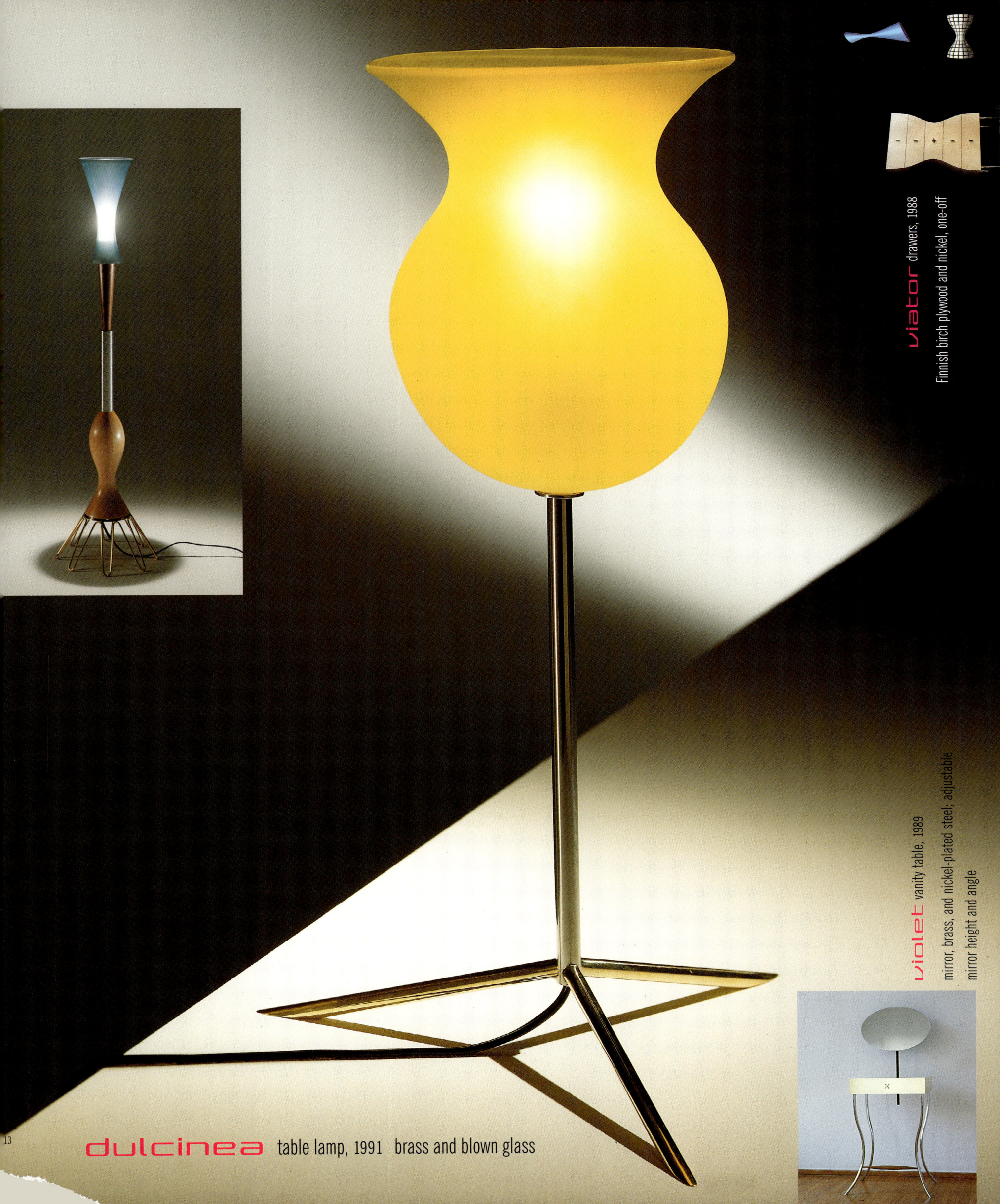

dulcinea table lamp, 1991 brass and blown glass

viator drawers, 1988 Finnish birch plywood and nickel, one-off

violet vanity table, 1989 mirror, brass, and nickel-plated steel; adjustable mirror height and angle

tower clock, Nambé, USA, 1996 polished metal alloy

shimmer frame, Nambé, USA, 1996
metal alloy and glass, positionable vertically or horizontally

wave frame, Nambé, USA, 1996
metal alloy and glass with spring clip, positionable vertically or horizontally

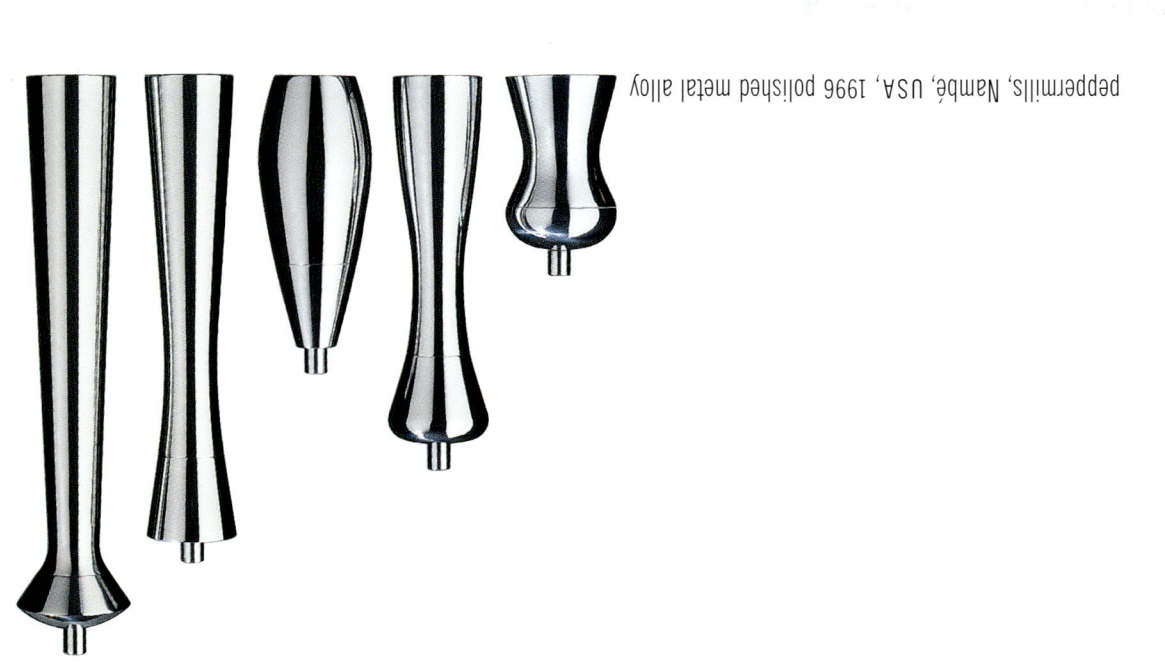

peppermills, Nambé, USA, 1996 polished metal alloy

klamp lamp concept for FLOS, Italy, 2000 polished die-cast metal alloy

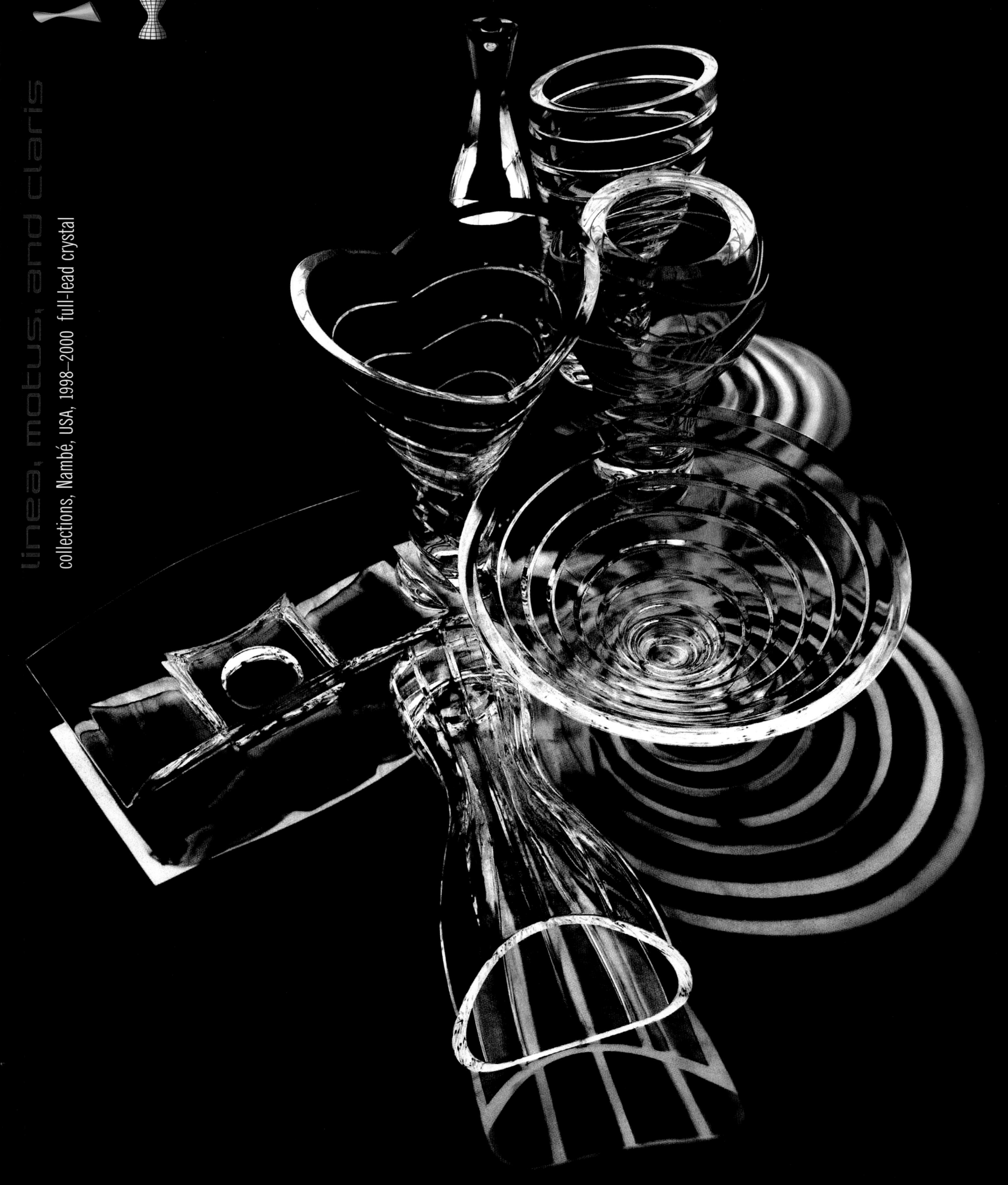

linea, motus, and claris
collections, Nambé, USA, 1998–2000 full-lead crystal

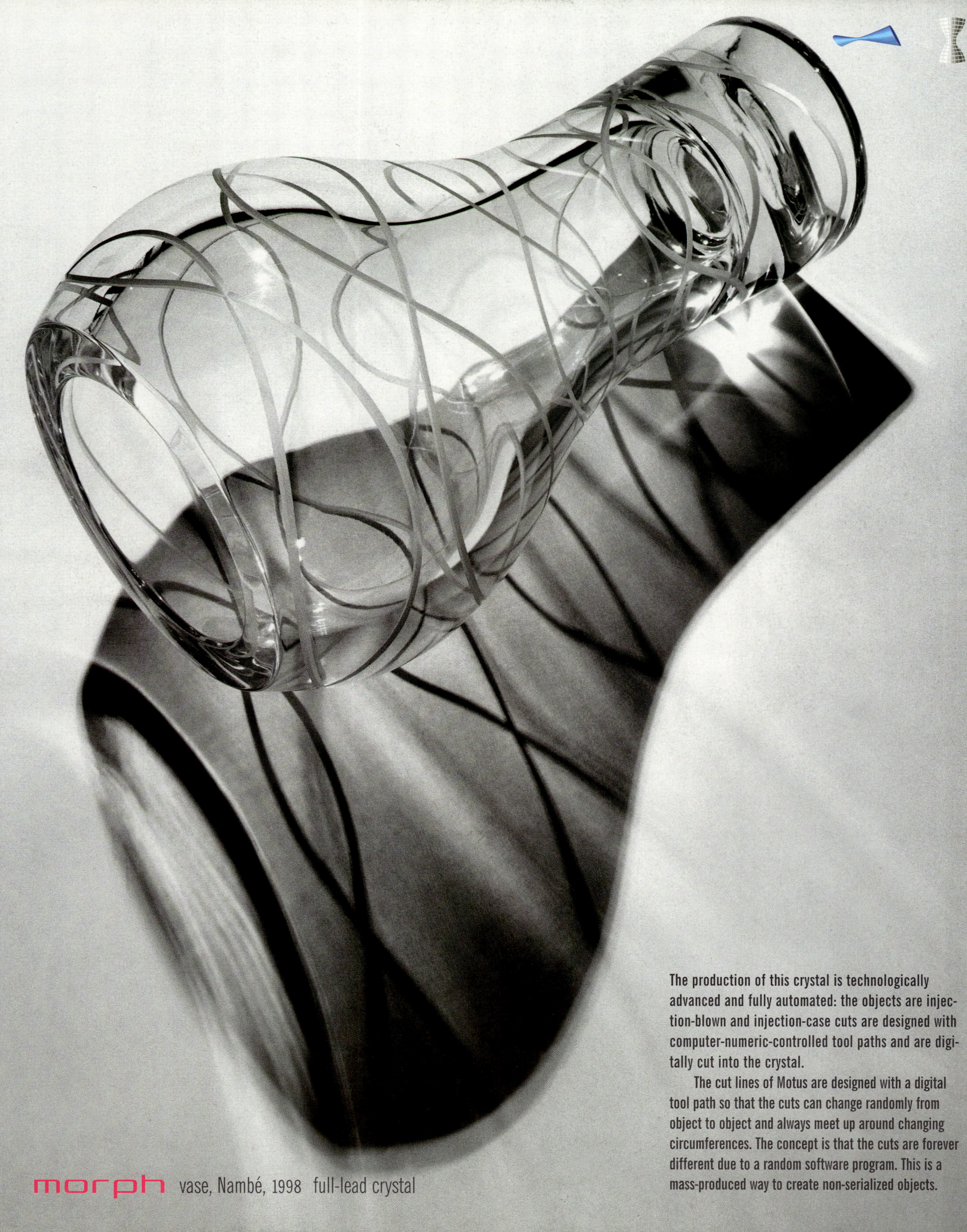

morph vase, Nambé, 1998 full-lead crystal

The production of this crystal is technologically advanced and fully automated: the objects are injection-blown and injection-case cuts are designed with computer-numeric-controlled tool paths and are digitally cut into the crystal.

The cut lines of Motus are designed with a digital tool path so that the cuts can change randomly from object to object and always meet up around changing circumferences. The concept is that the cuts are forever different due to a random software program. This is a mass-produced way to create non-serialized objects.

lucinda lamp, 1992 blown glass, walnut, and stainless steel

infinity vase, Nambé, USA, 1999 full-lead crystal

Nova candlesticks, Nambé USA, 1994 polished metal alloy

planar bowl, Nambé, USA, 1999 full-lead crystal

bowtie server, Nambé, USA, 1996 hand-polished, sand-cast metal alloy

variable napkin rings, Nambé, 1996 polished metal alloy

roulette bowl, Nambé, USA, 1998 full-lead crystal

starr rotationally molded plastic stool, Hidden, Holland, 2000

blossom salt and pepper shakers, Nambé, USA, 1995 polished metal alloy, digital production

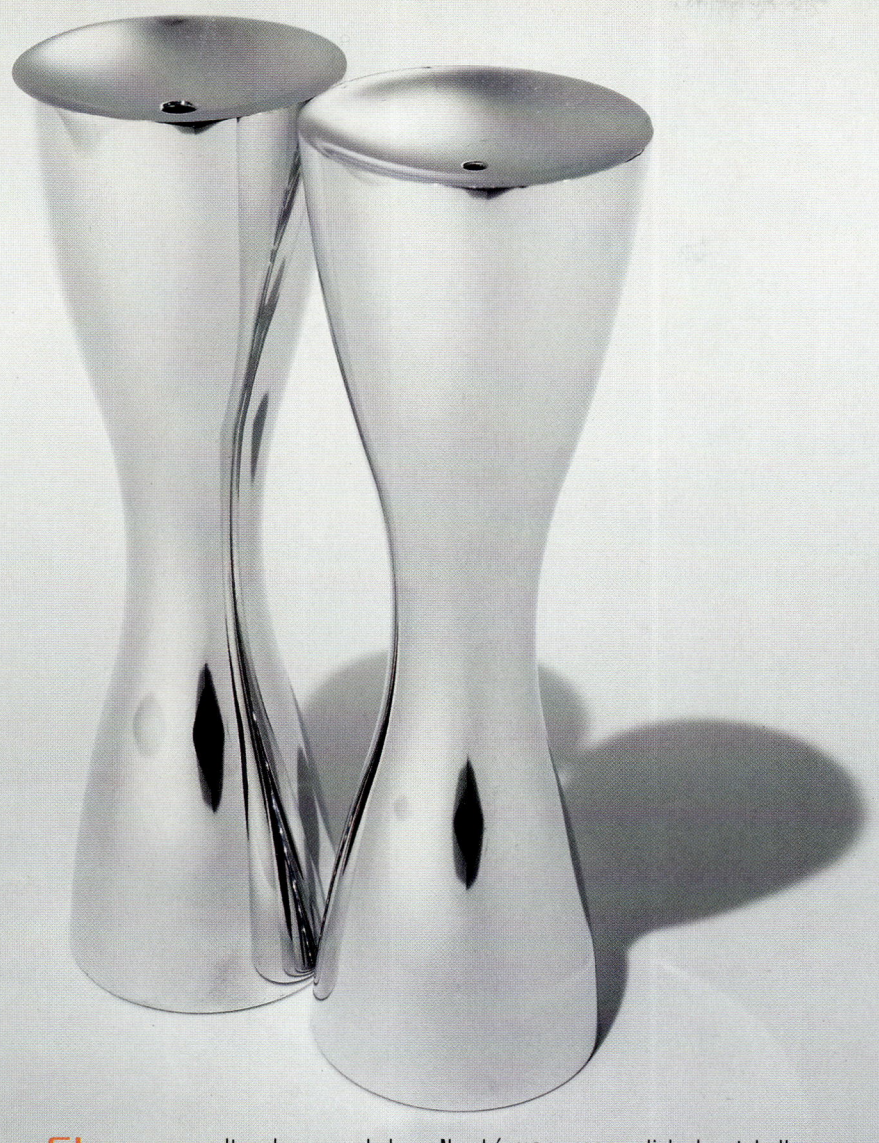

Flare salt and pepper shakers, Nambé, USA, 1995 polished metal alloy

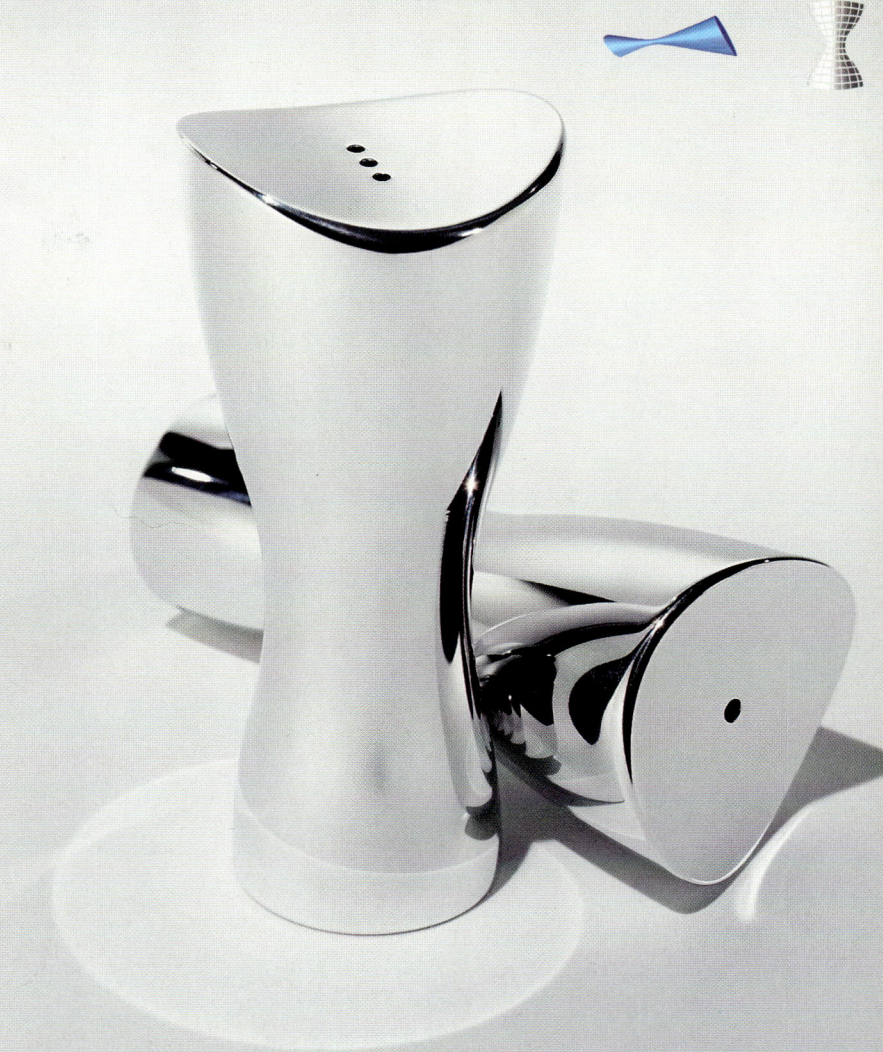

kismet salt and pepper shakers, Nambé, USA, 1995 polished metal alloy

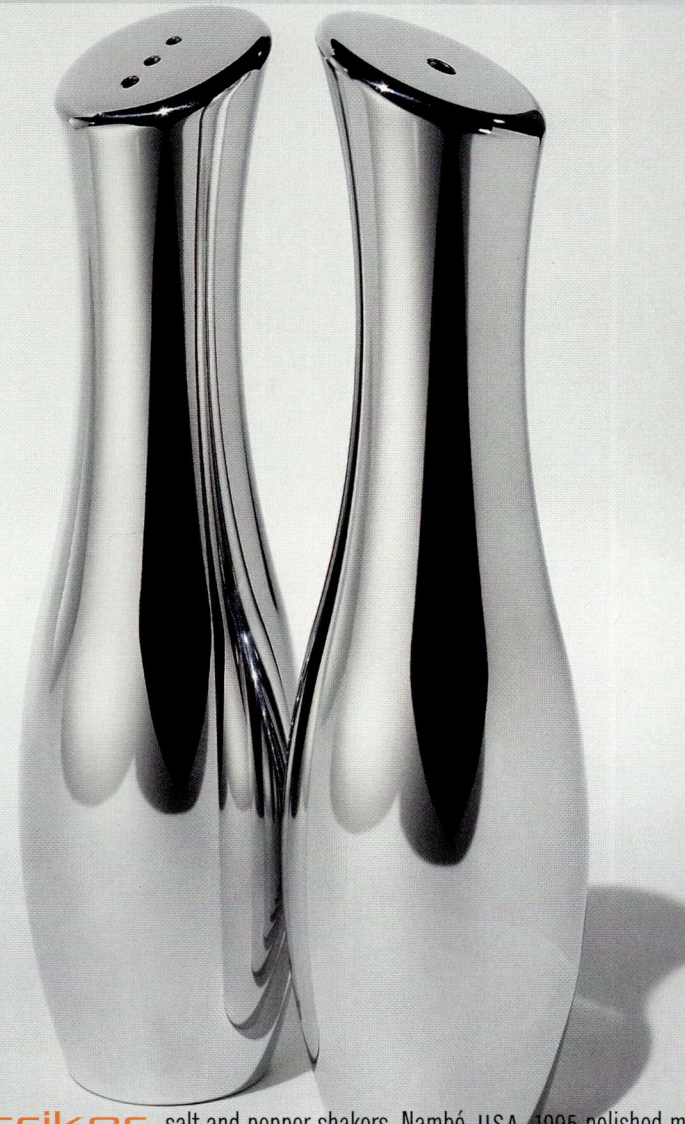

striker salt and pepper shakers, Nambé, USA, 1995 polished metal alloy

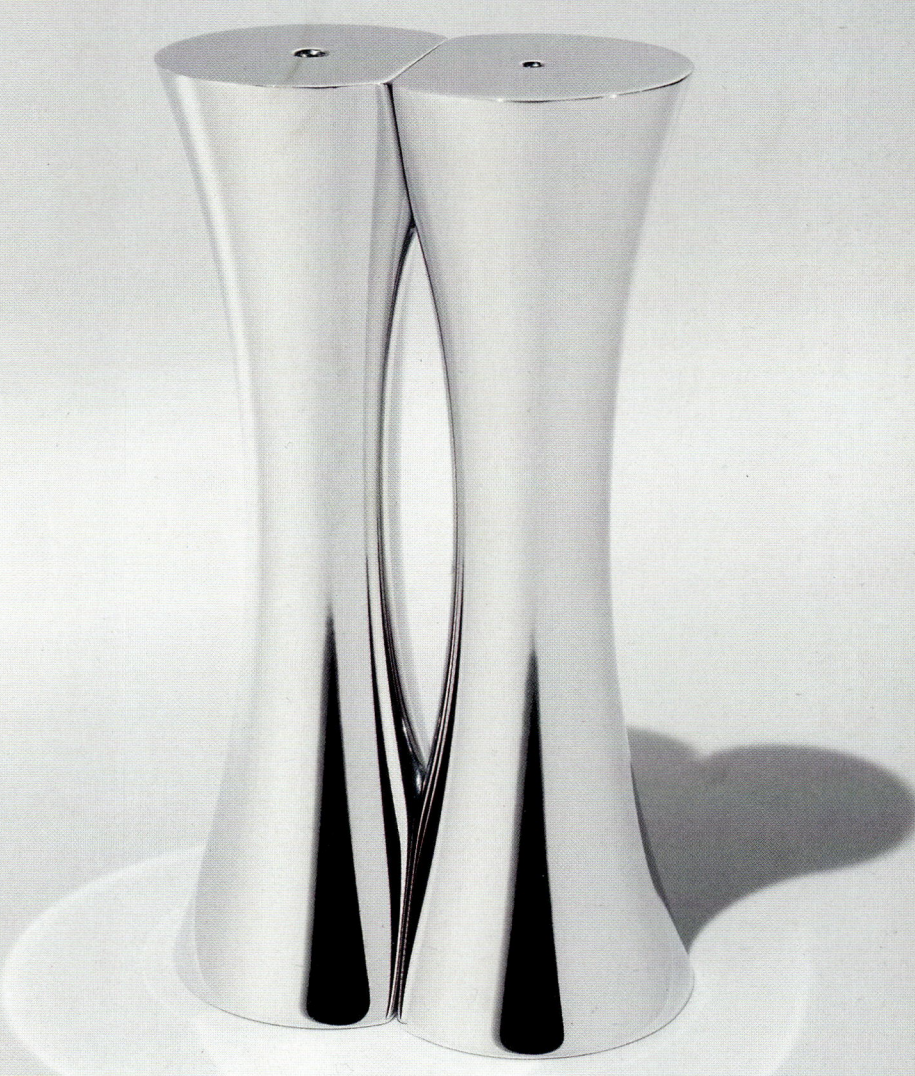

kissing salt and pepper shakers, Nambé, USA, 1995 polished metal alloy

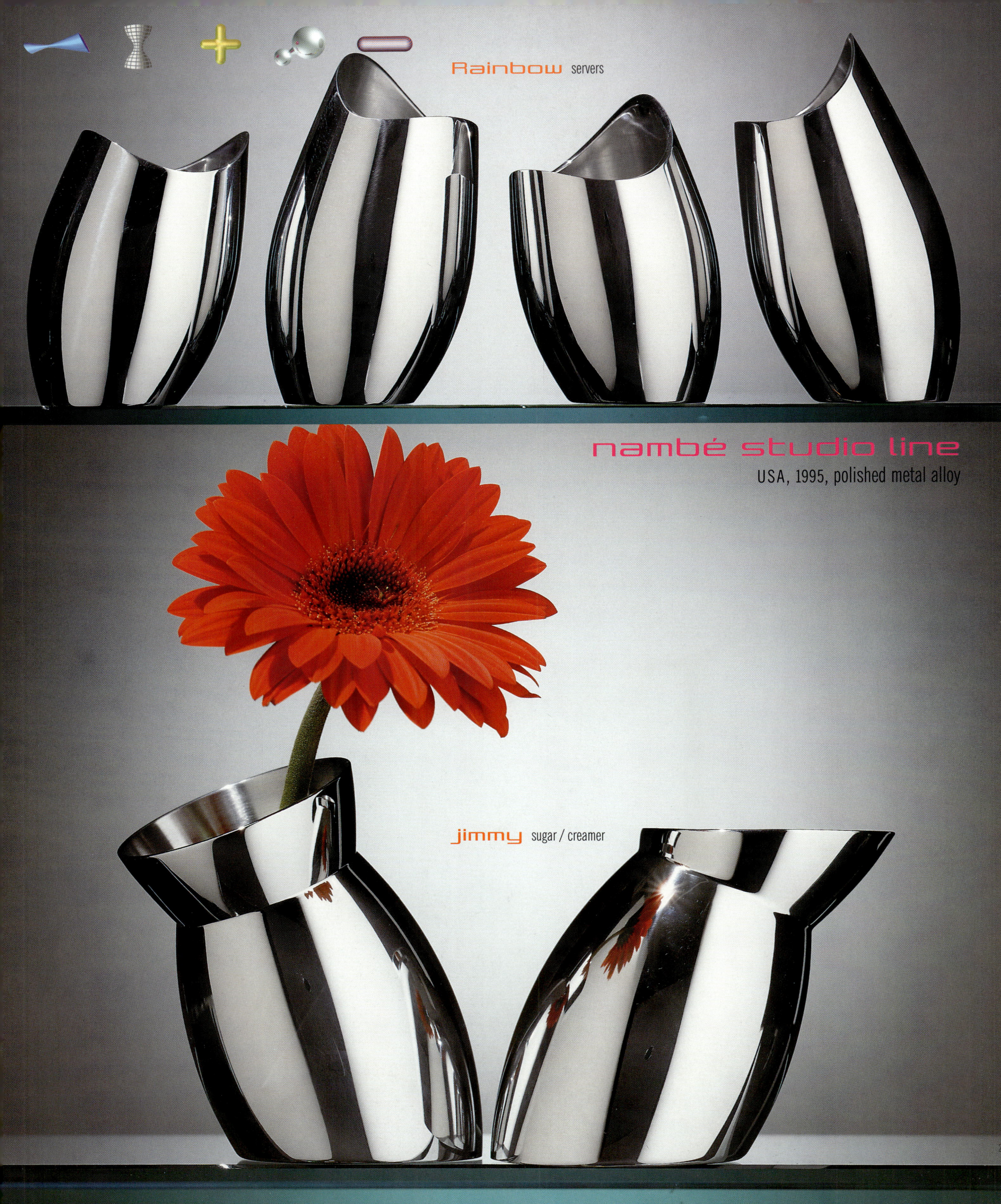

Leaning clocks

Fatboy clocks

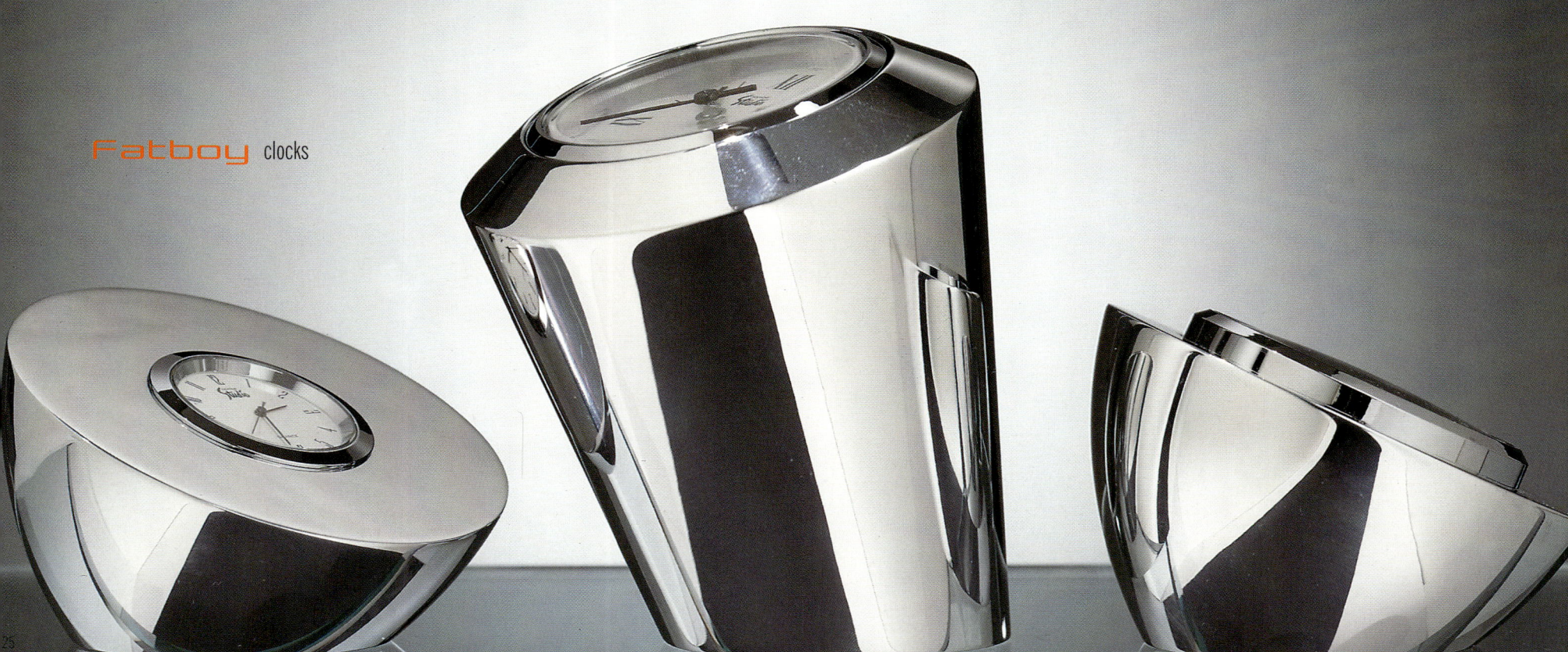

karim rashid variance

When we buy consumer products we buy into the myth that we are getting something deeply personal, because they happen to suit our individual needs, desires, tastes, objectives, fetishes, and lifestyles. Deep down, though, we know that countless others possess the exact same objects. But with variable production methods, the extraordinary can happen. More "designed product" has been delivered in the twentieth century than in any other era in history, at a seemingly lower cost than ever before. But actually, we've paid for it exorbitantly: just as individual workers have been subsumed by the relentless tedium of the assembly line, mechanization and its attendant serialization have wiped out the idiosyncrasies expressive of artful individuality. As the century draws to a close, however, manufacturing is on the cusp of a new era. Thanks to sophisticated computer technologies, smart materials, and innovative fabrication techniques, it is now possible to reengineer our approach to mass production, transcend the economics that have bankrupted much of what is designed, and develop goods that can be expressive and individual. Essential to this fundamental retooling is the commitment of designers to "civilize" production, to reconcile mechanization with humanity, and to embrace variance.

variance vases, Nambé, USA, 1995 polished metal alloy

As Model T's rolled off Ford's assembly line, more than cars were being mass-produced—consumers were being minted at the same pace. And as they drove away in their new vehicles, technology became the engine driving civilization with progress its destination. Everyone—it was hoped—would ultimately arrive at the rewards of speed, comfort, and efficiency.

With salvation seen in terms of commodities, people came to be defined by their membership in markets, and the voracious reciprocity of production and consumption was set in motion. Cued by experts in marketing, we have come to invest the goods we purchase with almost mythic capabilities; we're convinced that the things we surround ourselves with will not only function and make our lives easier or more satisfying but that they will help define our very identities. Ironically, most manufactured goods are standardized, with legions of replications owned by thousands, sometimes millions of us. Instead of individuality, they confer conformity.

The standardization of mass production precludes subtlety and distinction. Whether it's the generic impreci-

uno bowl (half of Bias), Nambé, USA, 1995 sand-cast metal alloy

sion of "one size fits all" or Henry Dreyfuss's measurements of "human scale" percentiles, what is lacking is responsiveness to the individual. No two of us are alike. And in a democratic society, we are free to indulge our ethos, our pathos, our likes and dislikes. By nature, our evanescent imaginations thirst for constantly changing stimuli. Drawn into the realm of discovery, we seek out alternatives and search for new possibilities. Though we know this intuitively, those who produce the innumerable goods that help establish the context of our lives offer a poverty of options, because what is available to us is dictated by the fashion of the moment and the need for business to make a profit. Fashion, while it changes constantly, encourages conformity and assures continued spending. Business, governed by profit, controls the availability of goods such that only those with mass appeal are marketed. Tooled as they are by the common denominator of maximum profitability at minimum cost and a homogenized vision of appeal, the commodities that comprise our modern material landscape are aesthetically impoverished.

But by developing systems and manufacturing methods that produce nonserialized objects, or by marrying up-to-date technology with requirements specific to each user, a designer can create products that are unique or that change over time, personalized by the individual. This is variance.

When goods were produced only by hand, each piece could be custom fit and bore the impress of human intent, incident, and error. Until recently, because it has been far too expensive to have our goods produced in such a way, consumers have had to be content with what is available at the mall or through the mail order catalogue. But this is changing. A new kind of precision is being made possible by state-of-the-art technologies, promising to empower designers. For the first time since the Industrial Revolution, the aesthetic concerns of the designer, the particular needs of the user, and the economic dictates of business are converging. This confluence of disparate requirements has the potential to restore industrial design to an empathetic and integral position in relation to the user. It also presents new realms of profitability for business.

Seeking new sources of revenue, business is realizing the untapped potential of niche markets. The old monolithic marketplace is slowly being dissected as marketers identify smaller, rapidly evolving "tribes" with constantly

bias server, Nambé, USA, 1996 hand-polished, sand-cast metal alloy

shifting demographics. This fine-tuning of responsiveness is beginning to foster entirely new expectations and desires. While seducing consumers to buy mass-produced goods continues to be the goal of advertising, the business community is increasingly aware of the fact that taking cues from consumers and supplying them with products tailored to their unique needs may be a good (and profitable) thing.

Variance has a number of manifestations. It can be random, achieved through variable production technologies. It can be defined in terms of use—whether through programmable capabilities, reconfigurability, or modularity. Variance can also be anticipated, wherein change occurs due to shifts in the properties of physical materials over use or time. Variance can be calculated, offering such a range of choice that a product is as good as customized; it can also mean a range of choice so great that variety seems endless. The perception of variance can also be achieved through the production of limited editions, so that only a few people own a particular object; they are buying the myth of variance.

Several years ago, the Dutch electronics company Philips produced a small pocket radio that was spray-painted in a random fashion on the assembly line. Consequently, each radio was unique, with a distinct graffitilike multicolor treatment, one that brings to mind the work of the German conceptual artist Rebecca Horn, who is known for (among other things) her paint-splattering machines. Admittedly, the radio represents random variance on only a surface level, but it is variance nevertheless, and it remains one of the few examples of a major manufacturer employing random variance.

Surface variance or decoration was elevated to essential form by British designer George Sowden in 1987 when he created a series of stainless-steel coffee press designs for Bodum. By designing a variety of patterns cut with lasers, Sowden made retooling for every form unnecessary. In theory, each and every coffee press could be

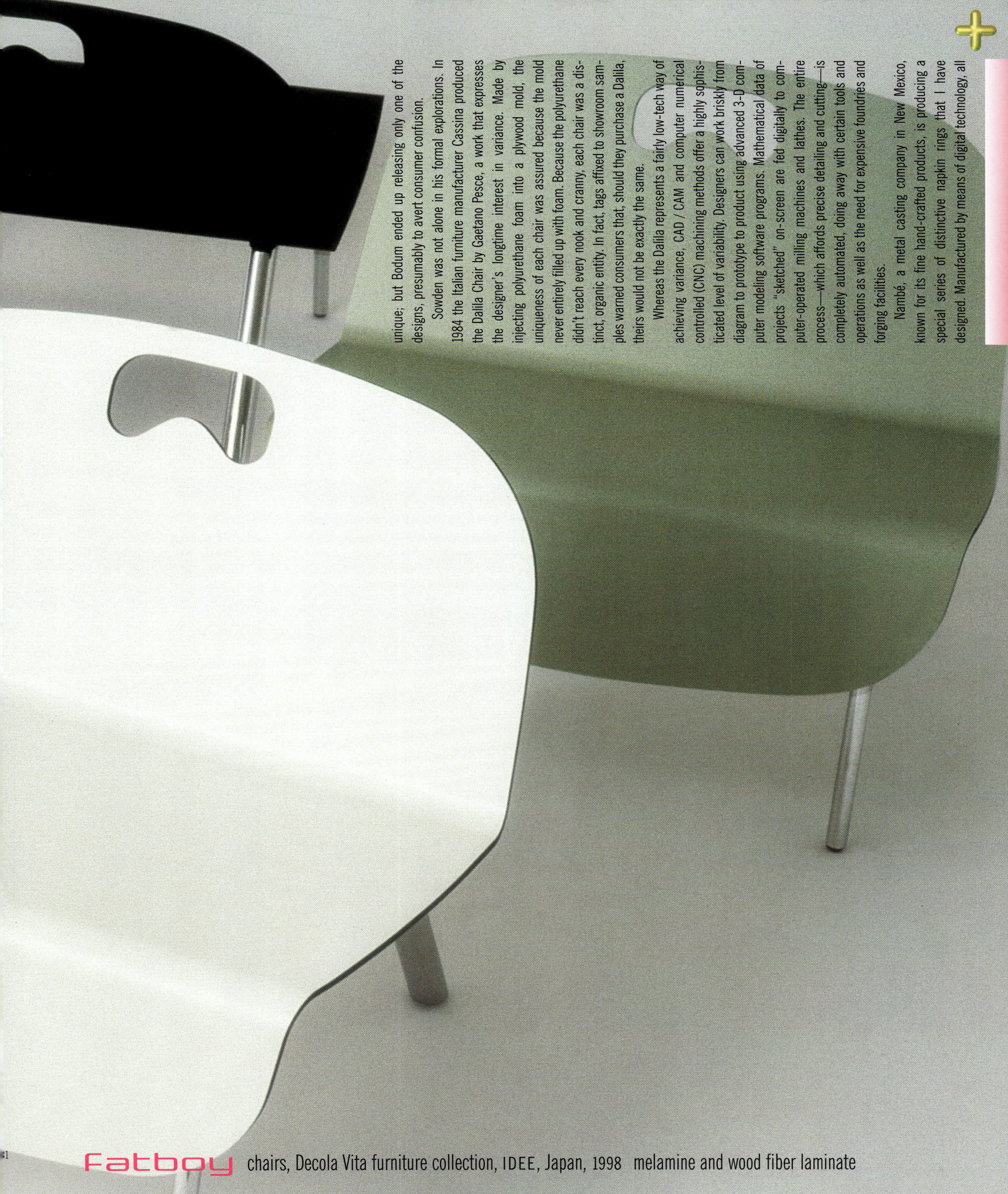

unique; but Bodum ended up releasing only one of the designs, presumably to avert consumer confusion.

Sowden was not alone in his formal explorations. In 1984 the Italian furniture manufacturer Cassina produced the Dalila Chair by Gaetano Pesce, a work that expresses the designer's longtime interest in variance. Made by injecting polyurethane foam into a plywood mold, the uniqueness of each chair was assured because the mold never entirely filled up with foam. Because the polyurethane didn't reach every nook and cranny, each chair was a distinct, organic entity. In fact, tags affixed to showroom samples warned consumers that, should they purchase a Dalila, theirs would not be exactly the same.

Whereas the Dalila represents a fairly low-tech way of achieving variance, CAD / CAM and computer numerical controlled (CNC) machining methods offer a highly sophisticated level of variability. Designers can work briskly from diagram to prototype to product using advanced 3-D computer modeling software programs. Mathematical data of projects "sketched" on-screen are fed digitally to computer-operated milling machines and lathes. The entire process—which affords precise detailing and cutting—is completely automated, doing away with certain tools and operations as well as the need for expensive foundries and forging facilities.

Nambé, a metal casting company in New Mexico, known for its fine hand-crafted products, is producing a special series of distinctive napkin rings that I have designed. Manufactured by means of digital technology, all

Fatboy chairs, Decola Vita furniture collection, IDEE, Japan, 1998 melamine and wood fiber laminate

the rings are identical in height, but each is in a set of four is slightly different from the next, and each successive set can be different again. The design of the rings is based on CNC digitally manipulated tool paths that, when shifted, alter the logarithm, changing the form.

As computer technology becomes more sophisticated, it promises levels of refinement in design that will compensate for the lack of craft skills, which have faded since the Industrial Revolution rendered the guild obsolete. Unfortunately, society can no longer accommodate or afford the lengthy apprenticeships that trained the master craftsmen who produced highly refined works. Although the handmade is ever to be valued, the cost of labor precludes production that relies exclusively upon the human hand. Increasingly, our tools are digital, and designers are poised to harness the capabilities of this new equipment with which they can create beautiful, useful objects that manifest a uniqueness and variety that the Machine Age stamped out.

Twenty years ago an unsigned rock band didn't have a prayer of producing an album unless they could scrounge up the funds to buy time in a recording studio. Today, audio technology has become so ubiquitous and cheap that anyone can record at home, using samplers, MIDI systems, multitrack systems, and CD recorders. And as recently as fifteen years ago, anyone seeking to publish a journal, newsletter, or flyer was dependent on the services of the local graphic or stat house. Now through digital technology, people have the ability to self-publish a wide range of printed material, from business cards to four-color ads. As the technology has gotten cheaper, desktop publishing has put everyone on equal footing, allowing for greater individual control and countless creative possibilities. There are more magazines now than at any time in history; on-line "zines" proliferate, along with hundreds of thousands of Web sites, mostly produced with little or no funding on home computers. Digital technology has given choice to myriad perspectives fostering great creative diversity and expression.

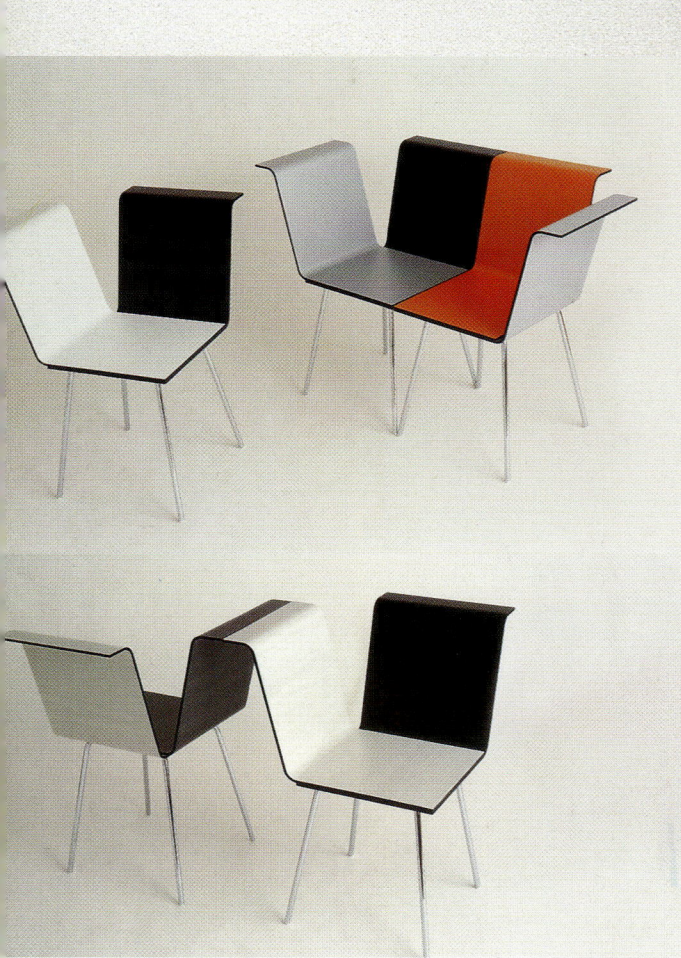

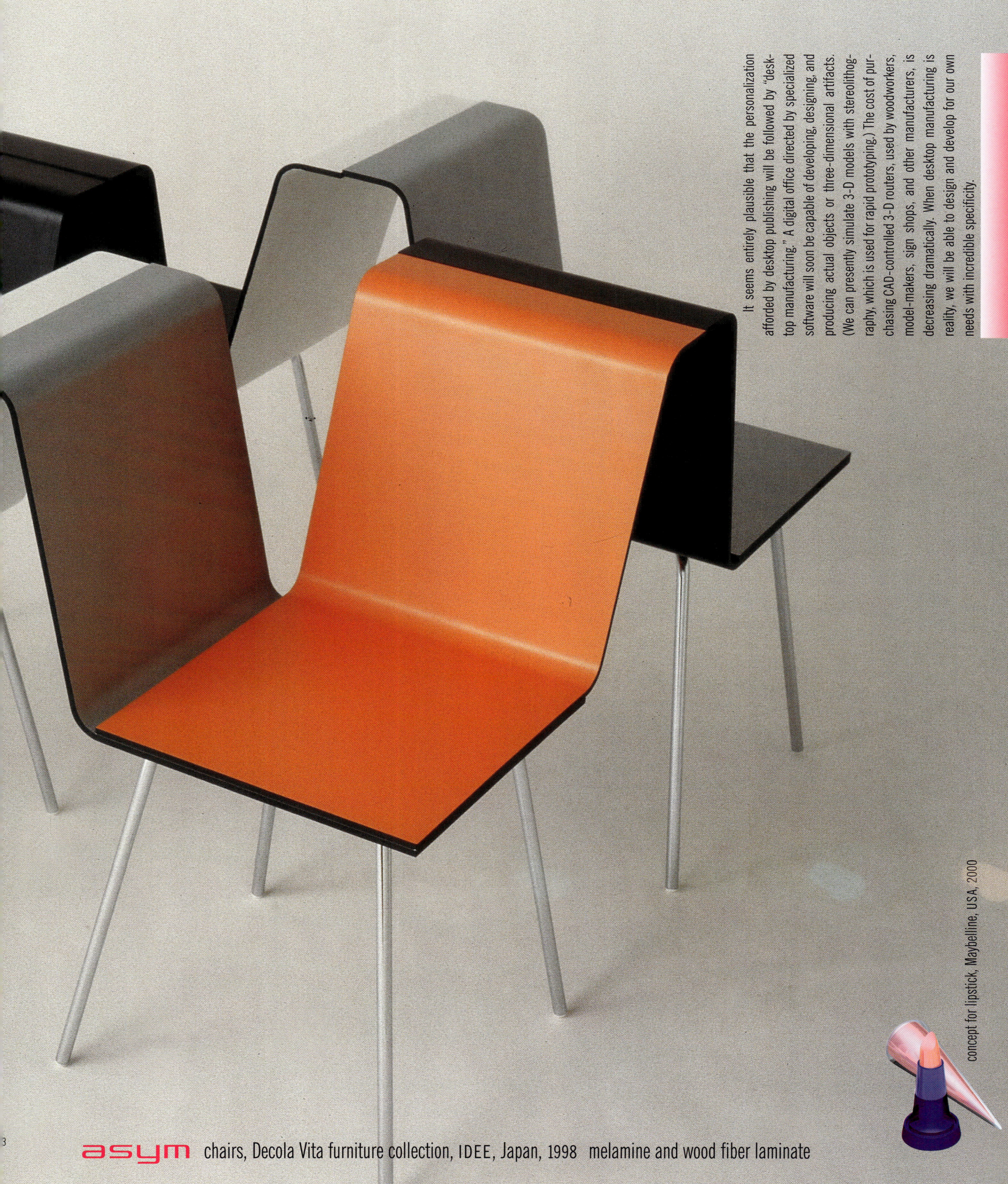

It seems entirely plausible that the personalization afforded by desktop publishing will be followed by "desktop manufacturing." A digital office directed by specialized software will soon be capable of developing, designing, and producing actual objects or three-dimensional artifacts. (We can presently simulate 3-D models with stereolithography, which is used for rapid prototyping.) The cost of purchasing CAD-controlled 3-D routers, used by woodworkers, model-makers, sign shops, and other manufacturers, is decreasing dramatically. When desktop manufacturing is reality, we will be able to design and develop for our own needs with incredible specificity.

concept for lipstick, Maybelline, USA, 2000

asym chairs, Decola Vita furniture collection, IDEE, Japan, 1998 melamine and wood fiber laminate

Although this still lies in the future, reconfigurability and modularism have been with us for some time. In the 1960s and 1970s, the American designer Harvey Probber broke up the sofa and produced modular seating units, and approach further developed and refined in Italy and Germany. In 1989 I designed Aura, a glass coffee table with at least eighteen configurations (depending on how its three differently tinted, kidney-shaped surfaces are stacked and interlocked). It is still evolving today, because I find that the elemental nature of a horizontal plane in space continues to generate many possibilities for rearranging. This variance of use allows tremendous flexibility in adjusting rooms for reasons of function or taste, much like a television studio can be altered to support different productions. Aside from compositional variation, the tints of the glass set up a further dimension of change on a perceptual level, as colors combine and recombine, and shadow and light continually shift as you walk around it.

More conceptually, I developed an installation for a 1994 exhibition in Tokyo entitled "The Personal Digital Environment." (The environment, although completely technologically feasible, was too costly to realize.) The space was "wired" through the floor with a grid of low-voltage current and data transfer capabilities, providing instantaneous tele-audio-sensorial communications. The furniture and walls were connected to the wiring, rendering them "live." The idea is that, through the manipulation of touch-screen or audio or brainwave feedback, the occupant can change the environment instantaneously, altering qualities such as light, heat, smell, and humidity. By touching the pellucid surfaces, images, text, and sound can be surfed, scanned, changed, and morphed. In effect, the room acquires a life, becoming the interface for direct or indirect relations with strangers, data, and imagery, and crosses the bounds of history, fiction and reality, time and space.

Some complex appliances and electronics, seemingly with capacity for highly intelligent decision-making, are available today. Programmed according to a set of mathematical rules known as "fuzzy logic," these machines are able to negotiate imprecise variables and probabilities, making them extremely responsive to varying circumstances. Panasonic markets a fuzzy logic washing machine in Japan that is equipped with an infrared beam capable of determining the amount of water needed and proper cycle length based on the volume of laundry and the dirt content in the water.

r30 chair, Decola Vita furniture collection, IDEE, Japan, 1998 melamine and wood fiber laminate

Fuzzy logic technology is used in Japan in everything from rice cookers to the Sendai subway system.

Also in Japan, the Tokyo-based design firm GK Dynamics conceived the Morpho II concept motorcycle in 1989 for the Yamaha Motor Company. Developed to be the quintessential ergonomic bike, its handlebars, seat, and foot pegs are all adjustable (forward and backward, up and down), to accommodate riders of all sizes and riding dispositions. Although the design has not been put into production because it is problematic to have moving parts in a machine whose functionality depends on stability, the Morpho II demonstrates an appreciation of the need to respond to the individual.

Another sort of precision and convenience is offered by smart materials like polymer resins. While we expect material to change due to weathering and age, smart materials anticipate variance—they can mutate into a desired state under certain conditions. For example, thermoplastic mouthpieces for athletes undergo molecular change when heated. To achieve a perfect fit, you submerge the device in boiling water and then hold it in your mouth for a few minutes while it conforms to exact contours of your teeth and gums as it cools. Another industrial material, nitinol wire, an alloy of nickel and titanium, has "shape memory." No matter how bent out of shape it becomes, nitinol will assume its original form when exposed to elevated temperatures. So far, its applications include a showerhead valve that automatically cuts off when the water gets too hot and wire-frame eyeglasses that when bent can be easily restored to their original form by immersion in hot water.

It is anticipated that nanotechnology will have a momentous impact on variance. By arranging a material molecule by molecule, atom by atom, the atom can become a modular building block. Developed through micro machines, using gears, levers, and switches of only two to eight atoms, such designs will be able to be self-contained, self-propelled, programmable, intelligent, and regenerative. Reassembling materials will be triggered by certain amounts of electrical current, light, heat, and pressure. We may well find ourselves one day in the world of objects morphing in response to just a touch or a small electrical charge.

Variance is already being achieved through far less complex means. Calculated variance, for instance, presents consumers with such a wide array of choices as to

3-in-1 travel kit
bottles for body lotion, eau de toilette, and bath gel, BPI perfumes / Issey Miyake, France, 1999 blow-molded polypropylene with adflex coating

king floor rack, Pure Design, Canada, 1997 steel rod chrome and wood knobs

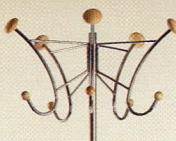

create the perception of customization. Levi Strauss & Co., Swatch, and General Motors, among other manufacturers, have engaged in this form of variance. Through Levi's personal Pair program, women can now order jeans cut to fit their bodies with a precision impossible with off-the-rack clothing. A clerk in the store takes four strategic measurements and feeds this data into a computer that determines which of the company's 4,224 prototypes suits that particular woman. The information is sent via modem to a plant, where a state-of-the-art computer-programmed laser cutting machine cuts the pattern, which is then sewn by a team of workers. Although a Personal Pair of jeans is not truly tailor-made, they are far more customized than a standard pair, at a reasonable cost.

Perhaps the best-known example of profitable variance is the Swatch watch. By simplifying the number of components, the Swiss company was able to mass-produce the watches cheaply, and then apply a large variety of decorative faces and straps that seem endless in their individuality. Beginning in the mid-1980s, each year several new looks were made available in limited editions. Their calculated variance helped turn a utilitarian object into a highly collectible commodity.

In the automobile industry, the pendulum of uniqueness has swung back and forth rather dramatically. Henry Ford's dictum that consumers could have "any color they like, as long as it's black," gave way over time to a fairly high degree of customization. Thirty years ago a car buyer was offered a wide selection of exterior and interior color choices, and options for features like air-conditioning so that a car could, in effect, be personalized. The cost of addressing individual needs, however, was a labor-intensive assembly line. The Japanese solution to this in the early 1980s was to produce cars with everything predetermined and included. But ten years later, General Motors saw an opportunity to distinguish itself and be competitive by introducing the consumer onto the assembly line. The Saturn is produced using robotics technologies, and prospective owners can choose from a panoply of options so great that the odds of replication of any given configuration are very small. This, combined with marketing that

 café stacking chair, Pure Design, Canada, 1999 powder-coated steel with silicon handle; at right: dipped in fluorescent vinyl

emphasizes the personal connection of the individual to the manufacturer, lends a human dimension to an industry that (somewhat ironically) is dependent on robotics. As robotics are further refined and developed, consumers seem to be the beneficiaries.

Like calculated variance, myth variance is founded on the perception of uniqueness. Instead of resulting from a wide range of choices, however, it depends on limited-edition runs, so that each person experiences such a purchase as a form of collecting. In Japan, the design firm Water Studio approaches larger companies that typically produce only high-volume unlimited production and proposes adaptations of their products to be issued in limited-edition versions. Water Studio has designed the Olympus Ecru camera, only 10,000 units of which were manufactured, as well as La Figaro, a retro-looking sports car made by Nissan, which produced just 20,000 of them. And this month, Apple Computer begins selling the Twentieth Anniversary Macintosh, a sleek, high-design hybrid of its Powerbooks and Power Macs. Only 12,000 of them are available worldwide, at about $7,500 each. While this type of variance is fundamentally a marketing strategy, it nevertheless fosters a more diverse and dynamic marketplace, with rewards for both manufacturers and consumers. Presently I am working on a vase with a smart crystal element that can detect and react to the acids from different flowers. The molecular chemistry causes the glass to change color depending on the time of day and type of flower. Admittedly, this is a simple, modest idea for an everyday object. Yet, just as flowers can arrest us—even momentarily—with their beauty, this vase could speak to the recognition that its current incarnation is distinct, unique, and, like a passing cloud, witnessed by the individual at one fleeting point in time. One is aware not only of the flowers and the vase, but of awareness itself.

Today, recognition of this order is in short supply. A mind-numbing sameness rolls over our visual culture, and a strip-mall mentality undermines both a sense of place and of particularity. The Golden Arches, which once denoted the American heartland, are annexing the world, from Moscow to Beijing. From airports to shops to hotel rooms, cultural distinctions are being erased, neutralizing the kaleidoscopic shifts of comparison and contrast that affirm our individuality and identity, effacing the topography of experience to a pint of amnesia.

Ours is an age of technological hypertrophy that, despite the explosion of options and functionality it has created, threatens individuality. In this breach of benumbing neutralization, designers can compose the idiomatic and variable, making our physical world not only more potent and humane, but more transcendent as well. For playing upon the diversity and richness of variance honors the individual, the senses and surprising the soul.

planar chair, IDEE, Japan, 1997 steel chrome frame, vinyl upholstery; back and seat are identical

planar sofa, IDEE Japan, 1997
steel chrome frame, vinyl and wool upholstery; back and seat are identical

space chaise, IDEE, Japan, 1999 steel chrome frame, reversible interchangeable neoprene covers and colored glass

Untitled, by Megan Lang

surFaise chaise with built-in flat screen monitor, Sandra Gering Gallery, 2000

wysiwyg coatstand, IDEE, Japan, 1997 15mm chrome steel tube, eight identical pieces, single production tool

elf stacking chair, IDEE, Japan, 1998 steel rod

electrolyte shelf / lamp, IDEE, Japan, 1998 can be produced at any length from a single tool, and placed horizontally or vertically

concept for wicker chairs, Umbra, Canada, 2000

electric slide concept for a chair, Cappellini, Italy, 2000

concepts for outdoor furniture, Sunlite, USA, 2000

q-chaise Umbra, Canada, 1999 urethane and slipcover

coffy table, Decola Vita collection, IDEE, Japan, 1998 melamine and wood fiber laminate

rad 16 table, Decola Vita collection, IDEE, Japan, 1998

TVC 15 serving cart, Decola Vita collection, IDEE, Japan, 1998 melamine and wood fiber laminate

wedji stools, Decola Vita collection, IDEE, Japan, 1998

ilight tables, shelves, and lamps (from one module), Decola Vita collection, IDEE, Japan, 1998

4infinity stacking chair, Decola Vita collection, IDEE, Japan, 1998 melamine and wood fiber laminate

askew tables, IDEE, Japan, 1998 melamine and wood fiber laminate

four tables become rectangle;
two tables become parallelogram;
two tables become square

ovolite two single couches and two ottomans, Galerkin, USA, 1999 four couches form an oval, ottomans nest inside

sofa 2 sofa with integrated chaises, Galerkin, USA, 2000 cushions pivot to form a double chaise, seats four or two

» There is a big difference between "design" and style. Style is surface and is about "borrowed" languages that are superimposed on anything and everything regardless
» of the subject. Design is about that specific subject, that typology, the issues of the project at hand. It is about redefining and refining the archetype.
» Karim Rashid

seven concept for a glass table, Lauder, 1998 over twenty configurations

wavelength bench, Nienkamper, Canada, 2000 aluminum cast legs with injection foam

teruo kurosaki Form to shape

When I was young, my father told me the story of a master sculptor of Buddha.

He carves the shapes of Buddha from a log every day for many years. Many young men learn from him to be a good sculptor of Buddha. A young apprentice, after many years of carving, reaches some heights of practice.

So the master takes him up the mountain and lets him observe all the trees in the forest.

He tells the young man to find a Buddha hiding in the log. He says, "If you cannot find a god in the material, you cannot let it appear and become alive. That is the meaning of carving a Buddha." Then he carves a log as an archeologist digs in the soil to unearth a statue.

We have developed more than forty designs—furniture and lighting—with Karim Rashid since he moved to New York City. He always tries to find the best shape in the materials. Today, our perceptions of natural materials have turned also to the so-called artificial. His attitude towards creation reminds me of the story of this sculptor.

wavelength

series, Nienkamper, Canada, 2000 aluminum cast legs with upholstered injection-foam seating and back single rail supports any length

32-bit color installation at Sandra Gering Gallery, USA, 2000 high-gloss kydex

concept sketch for L.A. Eyeworks boutique, Los Angeles, 2000

karim rashid

Nature is beautiful but excruciatingly dull, void of human intellect, human energy. We are nature but we are creating a technological, hypertrophic world. In the short time we are here, I find I am most inspired and most satisfied by accomplishing something, by creating some original thought or idea, and by having an impact on culture. I want to change the world. That may sound arrogant, but I only want to be one of many to create an eclectic farrago of lifestyles.

I have a great love for inspiring modern things. I see myself as someone born to create. The new objects that shape our lives are transconceptual, multicultural hybrids, objects that can exist in any context, that are natural and synthetic, that are inspired by telecommunications, information, entertainment, technology, and production. Objects we design can captivate the energy and phenomena of this contemporary universal culture of the digital age. New industrial processes, new materials, and global markets, which all lend hope to reshaping our lives, are my great interests in design.

i want to change the world

New culture demands new forms, materials, and styles.

My agenda is to contribute objects to our physical landscape that inspire, engage, and encourage positive experiences. I define my work as Sensual Minimalism, or Sensualism, in which objects communicate, engage, and inspire, yet remain minimal. They can speak simply and directly, without being superfluous. My work is a marriage of organic and pure geometry, of technology and materials. Soft, friendly organic forms communicate tactility and express a strong visual comfort and pleasure.

In response to excess, market seduction, and lack of sustainability, I believe that every new object should replace three. Better objects edit the marketplace. I have worked with companies to decrease their product lines, to streamline their production, to increase their efficiency, and to elevate the quality of their products. I act as design editor or cultural editor of our physical world. Replacing the saturation of objects requires higher quality and new ideas. We must develop products that are accessible to everyone to ensure that design is democratic. Good design, as far as I am concerned, embodies these six points: relevant, intelligent ideas; function, expression (semiological appropriateness and aesthetic originality); appropriate use of technology and materials; minimal impact on the environment (throughout the full product cycle); and high quality (including maintenance and durability). Good design can also alter human behavior and create new social conditions.

The object today is a proponent of an experience, the object's relationship with us, emotionally AND psychosomatically. Objects play into the conditioning of our behaviors: they dictate the way we live, the way we interact, the modus operandi of our conditioning. I try to develop objects that reduce stress—objects that bring enjoyment, not encumbrances, that simplify tasks and increase our level of engagement and beauty. Our lives are elevated when we experience beauty, comfort, luxury, performance, and utility seamlessly together. Content plays a primary role in the beauty of things. Paintings, objects, art, and architecture all manifest their aesthetics through their content. The visual and the concept are one. I call this Holistic Design.

I am interested in rethinking the banal, in changing our commodity landscape and proposing new objects for new behaviors for diverse markets. Design is extremely consequential to our daily life when it affects physical,

zoom coat hook and key shelf, Umbra, Canada, 1998 injection-molded metallic automotive polypropylene

psychological, and sociological behavior, and creates the conditions of human experience. I give birth to a multitude of things, both material and immaterial, that can shape our lives. My work is the study of alternatives and possibilities of commodity that interface society. As a designer I am an "artist of real issues" of everyday life, who mediates between industry and the user, between self-expression and desire, between production technologies and human social behavior. Products and furniture must engage our emotional lives and increase the popular imagination and experience. Diversity, variance, multiplicity, and change must be incorporated. Industrial design is a creative act, a political act, a physical act, and a socially interactive process that is greater than the physical form itself; its result is manifested in aesthetic forms, its content inspired by all the possibilities of our contemporary conditions. Design shapes our personal and commercial environments. The most important element of my work is that I try to design furniture that informs a sense of well-being, reflects the energy of our time, and includes some level of originality or innovation.

As technology becomes more democratic in the future, ideas will be the only way to differentiate between one manufacturer and another. Desktop manufacturing and variable nonserialized design, where products can meet individualized criteria and taste, are the challenges of the twenty-first century. Desktop manufacturing allows a consumer to build a three-dimensional object using a device such as a 3-D printer (similar to what is now referred to as stereolithography or rapid prototyping). Today individuals may create their own business cards or letterhead; tomorrow they will create or manipulate the physical things in their environment. Products, fashion, and accessories, interior space, sports equipment, and much more will all be highly customizable, highly personalized, and possibly designed by any individual.

Companies will market to smaller and smaller segments, tribes, and "specialized" groups, as the Internet is affording us today—even down to a market of one. A car, a fragrance, a pair of running shoes, and even body parts will be customized. Today this trend of Variance™ is evident in customized laser-cut Levi's Jeans, bicycle manufacturing computer configurations, and more. Manufacturers will greatly expand their use of new 4-D computer numeric machinery, toolless production, and other sophisticated production methods to make individually specified products

yahoo! bag concepts, 2000

in mass-production cycles. Consumers will soon be able to use a visual program on the Internet to morph, vary, and personalize a product and to digitally transfer this "toolpath" information to the manufacturer, who will produce and deliver the product to the individual.

Designers will become cultural editors, or cultural engineers, and "business strategists of culture." The design trend will be adding by subtracting: editing the marketplace with fewer, better objects. Design will be based on offering corporations originality and ideas that deal with contemporary issues, phenomena, and culturally relevant proposals. Today there are few ideas and many variations. Me-tooism as a business strategy is over. Businesses must differentiate themselves through innovation. Design and production will play critical roles in leading companies in new directions, and to new opportunities.

A designer will be a cultural purveyor: developing products that people want in order to elevate experiences, developing proposals that really change our lives and improve the experience of life. Design is the whole experience of living.

father's day kit packaging for L'eau d'Issey pour Hommes eau de toilette and alcohol-free deodorant, BPI perfumes / Issey Miyake, 1999 injection-molded polypropylene

kush modular seating system, Totem, USA, 2000 microcellular foam with Inmold coating, powder-coated steel legs

gear tables, from stacking table series, IDEE, Japan, 1997 colored glass and steel legs

quad and vector tables, IDEE, Japan, 1994

stacker table concepts, IDEE, Japan, 1993

amorphic tables, from stacking table series, IDEE, Japan, 1997 colored glass and steel legs

trispectra

table, Zeritalia, 1997 (original design 1990)
metal legs, shaped glass colored with the ColorGlass System

surfaise

chaise with built in flat screen monitor, 2001 acrylic and gel cushioning

heart chair, prototype, 1989

pilgrim chair, Area, Canada, 1985 natural rubber seat and back, steel frame

mailboxes

design for Canada Post, 1987
Pei stainless, cast aluminum, cast iron,
and compression-molded polycarbonate
modular system with interchangable components

sendai mediathèque

fiberglass information counter in Mediathèque building by Toyo Ito, Sendai, Japan, 2001

toyo ito

To stand before a giant fish tank at the aquarium is to experience the curious sensation of being two places at once. With only a clear wall in between, "here" on this side one is on dry land surrounded by air, while "over there" on the other opens an aquatic world. Not so long ago, aquarium tanks were relatively small affairs, peered at through windowlike openings in the wall. Today's aquariums, however, have impossibly huge tanks where awesome volumes of water press at us with awesome force through layers of acrylic tens of centimeters thick.

To see through walls like this represents a major paradigm shift, as different as architectural elevations and

fluid transparency

cross-sections. When looking through a window, the view beyond is inviolate, self-contained. Not so with a transparent wall: an environment that ought to permeate everywhere suddenly cuts off at an invisible boundary, leaving its sheared face fully exposed. A visit to the aquarium in days gone by was like going to the circus; now one is fully immersed in the experience.

Thanks to these new aquariums, we now have a clearer image of aquatic life, how the underwater plants and animals move in ways unimaginable above ground: particularly in deeper, previously inaccessible waters, where the increased water pressure makes the deep-sea swimmers lethargic, the swaying fronds heavy. Like the subdued dramatics of Noh theatre, all is continuous movement caught in a slow-motion time warp, each cell and body part suspended at half-speed. Moreover, the reduced transparency of water shows everything as if through a silk curtain: a gauzelike diffusion that sets the reality of things off at a fixed distance. One loses the vital physicality; we see glazed fruits floating in a gelatin universe.

In one project currently under construction, my initial image was an aquatic scene. Sited in the very heart of the city, facing onto an avenue lined with large beautiful cedars, a transparent cubic volume rises seven stories from a 50-meter by 50-meter square ground plan. Seven thin floor-layers are supported by thirteen tubelike structures, each irregular nongeometric tube resembling a tree root, thicker towards the top as it nears the soil surface, splaying and bending slightly. These hollow tubes are sheathed in a basketry of plaited steel piping, mostly covered in frosted glass. The effect is that of hollow translucent candles.

In the margin beside my first sketches for these tubes I wrote: Columns like seaweed. I had imagined soft tubes slowly swaying underwater, hoselike volumes filled with fluid. Without resorting to the typical wall-with-windows no-glass-facade dividing the building from the street, no clear acrylic plate out of a massive fish tank—I want to express the cut face to another world.

But why the aquatic image for a building on solid ground? For one thing, water is the primal shape-giver, the source to which all life forms trace back. Trees, for example, as they branch out recursively from trunk to twig to leaf-tip, resemble nothing so much as rivers that gather tributary streams and empty into the sea. The thick opacity of the trunk drives into ever-finer branches, gradually forming an intricate membrane, and finally

shop wrap desk, rotationally molded FRP, in Mediathèque building by Toyo Ito, Sendai, Japan, 2001

concept for a chair, Capellini, 1999

attaining the near-transparency of the leaves—the very images of fluidity.

If this is true of a tree aboveground, how much more fluid than those plants and animals which exist underwater? Their very forms embody such movement. As with fish fins, those parts that suggest movement grow more transparent further out toward the tips. Motion and form meet in fluidity, and fluidity is always translucent-to-transparent.

I am asking Karim Rashid for the furniture design for this project.

modular chair system in Mediathèque building by Toyo Ito, Sendai, Japan, 2001

karim rashid inc.

New York, 2000

>> I recently met Karim for the first time, downstairs
>> in the milk club in Ebisu. He came over to say hello
>> and to tell me how amazed he was at seeing my
>> new magnesium chair for Bernhardt. He talked with
>> great passion and sincerity about the modernity of
>> its lines and elegance of its construction, expressing
>> an honest respect for what I do. This led to a rich
>> conversation about the emerging world of form and
>> how to create it, a subject dear to the hearts of
>> those who view our world in organic sensual terms.
>> Our paths have often crossed by association or
>> comparison but from now on the generosity and
>> determination of Karim to succeed in his work and
>> friendships means that I will no doubt have the
>> privilege to thoughtfully argue the future with the
>> big man and his wonderful sense of destiny again.
>> Ross Lovegrove

LAndscape hotel

Los Angeles, California, scheduled to open 2001

PLEASURSCAPE sets a stage for a nonstop amorphous plastic scape that denotes a world with no boundaries. The space extends itself via plastic organic modules of repetition—a continuum of surface based on the conventional Cartesian grid of the gallery floor. Pleasurscape is a metaphor for a continuous world, a neutral landscape, and an undulating surface that is reconfigurable and extendable ad infinitum.

The entire 400 square feet of repeated forms are made from three modules that can be assembled together in various arrangements. The lightweight plastic moldings are rearrangeable to create a "built-in" lounge that is a growth from the ground—an extension of the natural landscape to the artificial landscape. All the notions of objects of comfort are dispelled and are replaced by an environment rising out of the ground. The continuous white field is surrounded by field of fluorescence to allude to the world of technology, to digital space and arbiters, as a recluse from infotrophy.

Inevitably our entire physical landscape will merge and connect. Furniture and space merge. Object and environment, City and town, water and ground, highway to highway, being to being.

Pleasurscape is part of the Pleasurnation—a a place and time for Solitude, the cocoon as the communal. It is a world that I am developing.

We talk, we watch, we sit, we touch.
We listen, we connect, we merge, we reflect.
We love, we hate, we maturate.

OMNI VINCENT AMOR OMNI VINCENT AMOK

pleasurscape kick back, relax, and chill, Rice Gallery, Houston, 2001

» The sublime, on the other hand, is to be found in a formless object, so far as in it or by occasion of it boundlessness is represented, and yet its totality is also present to thought.
» Immanuel Kant

ross lovegrove organomics

NEW NATURE, our inevitable organic future. As we begin a new millennium we are entering a unique era of reevaluation of ourselves and our habitat. We have reached a level of confidence in our creative abilities that is fueling an unprecedented level of inquiry in all fields from genetic engineering to fuel cells, medicine to the abstract depths of our organic universe. The process by which we are discovering new possibilities is being rapidly accelerated by computing technology, a technology that we always knew would open our minds.

Indeed, it is this concept of inevitability that intrigues me, especially when it is applied to the world we see and touch—our physical world. As the boundaries blur, this world will become stranger and less predictable, a fabulous prospect for those of us who believe that strangeness is a consequence of innovative thinking. The irony of all this is that ultimately, creativity generated by such freedom will lead humankind full circle back to nature, its organic composition, its purpose, and with it, to forms that will no longer be limited by our imagination.

Organic design comes from organic thinking; it moves people from the inside out stimulating deep primordial resonances that transcend superficial trends. So far we have only been guessing, but the beauty of the results from Moore to Frei Otto tend to suggest that a combination of raw intuition, combined with a degree of cellular, fractal logic, will begin to greatly influence the form and physicality of our manufactured world, from cars to architecture.

omni modular seating, Galerkin, USA, 1999 five pieces form an organic closed seating object

nuage tables, Elite, USA, 2000 glass and chromed steel

new american landscape exhibition, Deitch Projects, New York, 2000

8 couch concept for Edra, 1997

non-stop bench for Sendai Mediathèque building, Japan, 2000

momo100pink
100-seat bench for Belgian Biennale, Durlet, 2000

loungin sofabed, 1996

inFinity digitally produced wool carpet, IDEE, Japan, 1997

loungin chair, IDEE Japan, 1996 Wool upholstery with removable headrest / footrest, chrome legs

triaxial chaise / couch / bed, 1993
satin chrome steel with wool upholstery, nine configurations

Idee. Kuramata. Tokyo. 1986.

rad concept for reconfigurable self-skinned foam seating system, 1997

david shearer blurred revenue

There are two things that set Karim apart from many designers working today. The first is his unique vocabulary and how he expresses it depending on the materials or manufacturing process. When considering Karim's entire oeuvre—from his furniture for IDEE, to his injection-molded plastics for Umbra, to his hand-blown Venetian glass lighting for Kovacs—a language evolves that transcends the medium and a certain ideology becomes apparent. Karim defines it as "sensual minimalism"—sexy, timeless, functional, organic yet technological—the list goes on. The work is highly recognizable but somehow defies definition.

The other aspect of Karim's work that makes him stand out among his peers is the way he pushes the envelope when it comes to the actual materials and the technology that are utilized to realize the end product. The pure magnitude of the projects and clients that Karim has been involved with speaks of his incredible versatility when it comes to product development.

Karim has been instrumental in furthering the revenue streams of a number of his clients mainly because of his knowledge of the manufacturing process. His hand (and mind) can be seen at work for a diverse group including Issey Miyake, Prada, Sony, Leonardo, Magis, and Nambé. For instance, it has been Karim's influence on companies such as Nambé—a virtual icon in American table top—that have allowed them to expand their horizons and create whole new product lines such as the crystal line recently introduced. He also found a way that Nambe could utilize a manufacturing process to create products that are both mass-produced and one of a kind. This was a concept not necessarily recognized by the consumers buying the products but certainly one that builds added value and blurs the lines of art and design. In Karim's ideal world the objects themselves become the basis of our experiences and contribute to, and indeed, enhance our lives. Totem is an acronym for The Objects That Evoke Meaning, an idea that Karim would probably take one step further and say, "and the meaning should definitely be pleasurable."

commissioned pieces for private collector, Belgium, 2000

5 senses objects, Sandra Gering gallery, USA, 1998 125 limited objects

Karim Rashid home, New York, 2000

>> Nothing either in the ingredients or in the system is ever simply present or absent. On either side there are merely differences and traces of traces.
>> Jacques Derrida

wowowo sofa to sit front and sideways, Galerkin USA, 1999

eight and eye stools, IDEE Japan, 1997 chrome legs, industrial nylon upholstery, casters

arp 3 couch, IDEE, Japan, 1996 injection-molded urethane

karim rashid transconcepts

Everyone celebrates change, progress, and the future, especially in the home. I learned from an early age to embrace change, the engagement and endorsement of newness, and the love for inspiring modern things. Although change does not have to be new, it can be a flexible system that is perpetually reconfigurable.

I believe design is extremely consequential to our daily lives. Design is where we define and shift physical space, where we affect physical, psychological, and sociological behavior, and set up conditions of human experience. I would like to focus on a personal perspective on the design of new furnishings in our interior environments. Everything around us was once original. Nothing existed. We gave birth to a multitude of things, material and immaterial. These things shape our lives.

The world is changing. Its new objects are transconceptual, multicultural hybrids. These objects—be they design, art, or other—can exist in any context. They are both natural and synthetic, and are inspired through telecommunications, information, entertainment, and behavior. The birth of new industrial processes, new materials, and new global markets inspire ideas and paradigms that shape our lives. New culture demands new

arp armchair, IDEE, Japan, 1996

» Work always has concrete rewards. Juliette Cezzar

concepts, forms, materials, and styles. As we shift into the post-industrial age products are becoming more personalized as varied expressions of specific cultures, corporate identities, and tribes. Throughout history, shaping objects has shaped culture. Currently, industrial design has a responsibility to redefine these objects in society as a celebration of value and meaning, not as a celebration of surface. Designers develop forms and concepts that are informed through broader issues of changing cultural, social, and political phenomena.

Having reached the millennium, the most controversial design dialogue concerns excess, sustainability, and market seduction. The inevitable necessity to create new objects conflicts with the plethora and platitude of objects already existing. Many of the arguments instill a guilt and insecurity that drives young designers to switch from fields that deal with material production to the new financial lucrative opportunities of the digital and virtual market. Ironically, the momentum of industrial production is irreversible whether or not a designer contributes. Therefore the designer is more necessary than ever to ensure the quality of manufactured goods. Without them, the likelihood only increases that products will be knock-offs. Intervention in the manufacture process results in well thought out objects that could replace three existing ones. In an untamed world of eclectic choice, of various stylized programs, of supernatural endless variations, from the perfect seamless product to insatiable languages and functions, products require sophisticated manipulation. We have resolved most of our problems.

We do not need to solve "seating," but instead to design furniture that strives for meaning, for place, and time, in the catapultic speed of development and progress. The object must be perpetually reexamined; the variations of new materials, new technologies, new markets, new consumers must be investigated to contribute to collective experiences. Yet many utilitarian objects are not to be reinvented. Improving the original is difficult considering some objects have never changed greatly in centuries. The idea of starting with a simplified "first order" point of entry in the design development, where we do not start out with the archetype or with the intention of imitation, keeps the subject contemporary, the language simple.

My interests lie in rethinking the banal, in changing our commodity landscape and proposing new objects for

dakis lounge / work chaise, 1996

» We live everywhere in an aesthetic hallucination of reality. jean baudrillard

new behaviors for diverse markets. Be they design or art, the societal contribution is the same. Our entire design and production process today is digital. We can design for complete advanced production methods omitting any handlabor. Assembly lines and repetitive motion are inhuman. If machines can do it better let them do it. We have other things to do.

One hypothetical model for a rave new world is based on a scenario where no product exists for more than five years. Every object would have to be perfectly cyclic as not to collect as waste. Generations would not be able to pass down anything in its original form. Simply the idea of antiquity would be a simulation. Art and design must engage emotional grounds and increase the popular imagination and experience. Originality, expression, content, meaning, and change are all constructs of the whole. Our objects in our lives would be biographic. Objects are lust.

The argument is not about the physical process; it is about the result. Not crafted, but mechanistic, not the effect but the cause, not technique but ideology, not the incidental but the program, not the myth but the manifestation, not just appearance but the utility, not unique but serial. Either employing an intellectual didactic, or an empirical heuristic process with aesthetic, cultural, and experiential results. If art asks questions can design also question/ radically contradict, redefine, and communicate messages?

Through documentation and galleries, we experience art intellectually and emotionally, but it is in limited visibility and experience. Design is learned through interaction. It is highly interactive and accessible; therefore we can experience its actuality, its form, color, material, ergonomics, performance, cultural and market relevancy on an every day basis. But can Design question status quo as art does? Does art need to be unique? In design's case, the original is the drawing, the *pneumanon*, the schematic, and the prototype. These are unique one-off developments in a process in which the object is intended to be produced in quantity; it will be developed into a serialized replication of itself. The tool, the computer-controlled machine, the mold, and the industrial material produce numerous identical units. These same industrial processes are becoming more and more tools for artists. Artistic interests have shifted to industry and objects of our daily lives. I see many artists very interested in the serialized, versus the non-serialized, the unique. I am obsessed with this fine line of

limacon sofa, IDEE, Japan, 1996 injected foam, no frame structure

prediction and tooling methods, versus the one-off. Works by such artists as Jorge Pardo, Julian Opie, Rachel Whiteread, Donald Judd, Roxy Paine, and Andrea Zittel are addressing a shift into our industrial system. Jorge Pardo works in the arena of mass design. Roxy Paine proposed a robotic painting machine that with digital random control would dip a canvas into paint for a random amount of time and pull it out of the paint for a random drying cycle time. Barry X Ball works with Corian and although based on renaissance architecture he uses CNC industrial machining in order to render unique sculpture. Experiments with rapid prototyping machines and short-run injection, or roto, blow, compression casting and other industrial methods are defining a new art, a Post-Industrial Art. Can we let machines produce art? Or redefine it? I see new typologies of art ready to emerge. As art shifts towards the serial, to the duplication of the thing, design ironically shifts towards small batch production, limited edition, one-off and non-serialized goods with such methods as random numeric computer control.

The design process is changing due to new software and new digitized production technologies. As computer technology becomes more sophisticated, it promises higher levels of refinement in design that will compensate for the craft guilds that have declined since the Industrial Revolution. Traditionally, these crafts sought for the same identical "replica" or simulation. In some sense the repetitive "hand-crafted" object was not craft anymore but a low-tech hand labor assembly line. Craft was interested in reaching a perfect state, of identical nature.

The mechanization of the twentieth century left no choice for craft but to diversify its serialization. Society could no longer accommodate or afford the lengthy apprenticeships that trained master craftsmen in producing highly refined works. The hand-made may be forever valued but the cost of labor precludes production that relies exclusively on it.

Mass production had become very sophisticated in its name of identical perfection, efficiency, and cost-reduction. So craft became more involved in the 'one-off' as a middle-class leisurely profession of self-fulfillment. Ideal 'Craft' should express variance: each piece altered from the next by human intent, error, or human incidence. Contemporary craft is produced out of the autonomy of will and self-pleasure and not as a trade steeped in labor. In

concepts for bent plywood chair, David Design, 2000

arp 2 chair, prototype, 1991 elastic webbing on chrome steel frame

turn, diversity was also increasing in mass production during the early part of this century. Simply surfacing the product was the fastest and simplest way of giving a consumer choice. Diversified products increased sales, and eventually it allowed the assembly line workers to be exposed to different jobs to 'diversify' their tasks in order to render a more productive and interesting position.

I propose Digital Craft as a new concept, to produce nonserial objects *ad infinitum* using mass-produced production methods. The idea is that one can produce objects in a very fast cycle using software programs that randomly change the tool path geometry creating one-off objects. These products can take on new personalized meanings through their greater differentiation and diversity. They can address new markets as well as redefine and literally reshape universal industrial commodity. Modernism created the mass-produced "identical" object that eventually lost its meaning, value, and expression.

To design within the limits of technology today means to design with complete autonomy. Understanding the opportunities of production shifts puts greater emphasis on the idea—the concept of systems, the concept of change, and the concept of meaning. Design and production are already inseparable as Design and Art will become inseparable. With digital randomness and robotic production, there is no original and in turn no art, and in turn no craft. Ideas will be set free in motion and possibly become less classified. The future will celebrate the object in society, an object unlimited by production. We are amidst a Post-Industrial Age, an age where autonomy, diversity, change, and vicissitude can exist in harmony and technological manifestation.

CAD drawing of chair, 1986

kid chair, FASEM, Italy, 1991 leather, canvas, and steel tube

As technology improves objects and products, fashion, and accessories, interior space, sports equipment, etc. will all be highly customizable, highly personalized, and possibly designed by any individual. This trend is called "desktop manufacturing," which allows a consumer to build a three-dimensional object using a device such as a 3-D printer (similar to what is now referred to as stereolithography or rapid prototyping). Besides individuals creating their own business card or letterhead today, they will create or manipulate the physical things in their environment.

Companies will market individualization to address smaller and smaller markets, tribes, and specific specialized groups, as the Internet is affording us today. A car will be completely customized down to the body form, a fragrance will be totally customized, a pair of running shoes, and even body parts. Today this trend of Variance™ is seen in customized laser-cut Levi's Jeans and, bicycle manufacturers, computer configurations, etc. Manufacturers will utilize new 4-D computer numeric machinery, toolless production, and other sophisticated production methods to product in mass production cycles, one-off individually specified products. The other scenario is a consumer using a visual program on the Internet to morph, vary and personalize a product. This 'tool path' information is digitally transferred at the manufacturer site and then produced and delivered to the individual.

The design rappinghood is where a plethora of shapes, materials, mechanics, electronics, digitalia, information, myths, markets, tribes, all form an ever changing dynamic parabolic cosmos of our built environment. It combines with the human body, softness, tactility, coalesce into new languages. All these components inform form. Minimalism lacked the human aspect due to its sacred geometric language that was removed from history and nature. Design now redefines itself. I like design that traverses the boundaries of the associative and touches the sensual, that goes beyond the modernist doctrine *bel-nahe Nichts* (almost nothing). I define new design as sensual minimalism or sensualism, where objects communicate, engage, and inspire, yet remain fairly minimal *a posteriori*. They can speak simply and directly, without being superfluous. These new objects can be smart, fuzzy, or low-tech, all informed by these new factors. The marriages of organic with pure geometry each carry significance, symbolic of a personal language. The new materials are reflective,

spline armchair, IDEE, Japan, 1997

smooth, glowing, pristine, glossy, mutable, flexible, tactile, synthetic, high contrast, sensual, cold and hot, organic, chrome, liquid, glass, lacquered, fluorescent, smart, interactive, and illusory. These materials formulate and inspire new languages.

As we exist more and more in a virtual world, our physical world will develop a new importance. Our furnishings around us will become special considerations, more beautiful, more diverse, and more personal and they will not be necessarily isolated but rather they could develop into integrated ways of living. Our future furnishings will be technological. Objects will become intelligent (intellijects.) Our own skin could become the interface for telecommunications devices. High tech and low tech will merge. Everything will be unique. We will create a new industrial / digital Language—a digital or Electronica aesthetic.

Art embraces contemporary myth, with contradictory results. Design also celebrates contemporary myth, but solicits less value. As soon as the art object shifts into the role of utility, or implies a functional role, the value shifts to 'things of everyday life'. Why should commodity of everyday life carry any real value, especially as cultural artifact or preconsciousness? The ubiquity of produced goods does not necessarily de-value their presence. As Duchamp's ready-mades shifted our view of the banal object, and questioned art, mass consumer goods today shift our view of art from sacred to kitsch. Examples of such being Warhol wallpaper, Cocteau dishes, Munch's "Scream" as an inflatable doll, T-shirts with Van Gogh on them, screensavers, etc. Disposability, change, and new technologies all speak of a vast inertia of consumption, of less value. Eames chairs, although considered critically important to American history, have distant perceived value, yet millions were produced, hence why there are so many in circulation. It is equivalent finding "Saturday Night Fever" vinyl LP's in Salvation Army stores.

So how is it possible that design can infiltrate into the context of Art? And can Art exist within the realm of hyper-consumption, of multitudes of new models, as the machine of fashion, trend, and consumption? Should it? What is art's real contribution, and how does art distinguish itself, from all of the imagery we see everyday in the media? Is real art now part of the commercial world where real art

aphex chairs, IDEE, Japan, 1997 Japanese aerospace nylon with reflective 3M stripes

pushes greater boundaries and higher aesthetics, and has a greater amount of experimentation at a belligerent pace?

Periodicals have revolutionized font, layout, and image. The images that surround and inundate our consumer lives today are more beautiful, more seductive more content laden. Desktop publishing afforded us complete autonomy with image and font. Now desktop manufacturing will revolutionize our physical landscape. With desktop manufacturing we can design 3-dimensional models in front of us, design customized, personalized three-dimensional objects. Technology bifurcates art and everyday life. Its speed and sophistication is immediately embraced by businesses to market goods, film, television and other media. Artists tend to lack the resources, the funding, and the knowledge needed to be able to embrace these new technologies. Hence, they are not able to keep up with the digitalia of our technological world. Many video artists show us the equipment with passion, (look at this great technology) as their eye sees beauty in cables, mechanisms, and digital tools. Meanwhile, the artwork is lacking in content. We are already familiar with technology on an every day basis. We have it in our recrooms as well as in our offices. People in their private and public lives are digitally documenting, printing, telecommunicating, infotaining, interacting, surfing, morphing, manipulating, and transforming the real and unreal. The boundaries between fantasy and reality blur. We have seen Hollywood, in all its 'non-art' film making, develop amazingly abstract imagery and effects. We have gone beyond the scope of art via our media, our digital existence. The inertia and momentum of high technology in contemporary consumer goods and culture reinforces the speed at which technology ages. Whether highly technological or low-tech and mechanical, artists and designers must generate 'concepts' - to develop relevant and intelligible ideas, that will endure the coming and going of passing technologies and heighten our everyday experiences.

spline sofa, IDEE, Japan, 1997

his and her freedom packaging for Tommy Hilfiger eau de toilette, Estée Lauder, France, 1999

sofa one sofa with integrated shelf, Galerkin, USA, 1998 cushion pivots to the back to form a chaise

Karim Rashid home, 2000

aaron betsky

Karim Rashid freezes flows. The undulations of his forms move with the fluidity of things that are not so much natural as mineral. These are not bodies of either human beings or animals, but metal revealing the molten state out of which it came and plastic clear about its plasticity. Rashid makes blobs that are the result of computer programs as cold as ice. They are data made real, tangible, with weight. This is a wholly unnatural beauty. It is also very popular.

The computer has obviously liberated designers to create almost any form they would like, and in fact encourages shapes that eschew facets in favor of continuously modeled surfaces. Rashid is a master of such forms. He is (perhaps only with Marc Newson) the first true stylist of such data-driven fluidity. Just as the great industrial designers of the prewar era harnessed new technologies and theories about mechanical expression to forms whose smoothness made these abstractions of modernization into sensual reality, so Rashid is turning the fast flows of the electrosphere into seductive commodities.

There is a theory behind all of this. Advanced by theoreticians such as Greg Lynn and Ben van Berkel and

Free Flow

Caroline Bos of UNStudio, it proposes that either the nature of how form emerges out of chaos or data itself can in and of itself create form. To these thinkers, bloblike shapes are the most natural and appropriate results of the revelation of science and technology proper to our more transparent world.[1]

Drawing on language developed in physics, Lynn has pointed out that a "blob" is actually a technical term for an object that is the result of the amalgamation of material around attractors emerging in epigenetic landscapes. The blob's complex shape comes about because of the way material groups itself around such points of attraction and elongates as the result of other forces within the system. Blobs are not so much containers of space, as they are accumulations of data in that system made into a physical reality.[2]

To van Berkel and Bos, data courses around us everywhere. It exists as zeros and ones, but also as tabulations of the forces and regulations: square footage requirements, safety regulations, gravity, wind direction, and all of the myriad other factors that go into carving out our world into habitable space. The task of the designer is to calibrate these forces so that they become coherent buildings or objects. They see their work as not giving a face to economic or physical forces, nor the shaping of space in contradiction to such forces, but as the direct molding of this multitude of data so that coherent form and space emerge.[3]

There has been little theorizing of such forces in industrial design. Malcolm McCullough, in *Abstracting Craft: The Practiced Digital Hand*, has pointed out that the immense freedom computers give designers demands a completely new relationship between how things are seen by the maker and how they are then made. Instead of the form intervening between idea and result, form becomes that which actually bridges, as an extension of the body manipulating a keyboard, between the virtual and the real.[4] Form becomes an accumulation of material rather than a construction and thus has an innate relation to abstract modes of thoughts. It also liberates the appearance of thing from production: "Thanks to CAD/CAM, and more controllably than ever before, images can become things."[5]

There is, however, a tradition native to discipline of industrial design in which we might be able to see Rashid's work. It is the notion of streamlining. Though we associate it today with a certain look that appeared in the mid-1930s in the United States and, almost simultaneously, France, its inceptor, Malcolm Loewy, theorized it as a way to move

>> one must live with the things they design. this is the true test of time. Karim Rashid

the American economy out of the Great Depression.6 He believed that the smooth forms would remove barriers to consumption, both in terms of overcoming buyers' resistance to a monolithic object and by making the objects easier to use. Streamlining also came out of research into the best ways to reduce wind resistance in vehicles (originally through forms developed for ships), and expanded into the field of ergonomics and human factors, where it was supposed to be a way of making objects more directly responsive to the human body.7

Here theory became fuzzy and science intuitive or based on subjective audience research, so that forms became multitudinous and always changing. They also met up with influences coming from the world of art, where the notion of organic form as a defense against mechanization and rationalization, a return of the repressed and an expression of the underlying biological nature of all existence led to a "blob-ism" that by now has venerable a tradition as the scientific one identified by the likes of Greg Lynn.8

Finally, in an era which has moved beyond the direct expression of technologies through fantasies of transparent design disappearing into engineering, reason, and the reflection of a milled surface, Rashid has picked up on the current interest in the ambivalence of the object itself. Since we now realize that something remains even after all has become rational or economically defined, we also realize that the work of art or design might be constituted by the manipulation of that rest. The memory of humanity's—and its creation's—physicality resides in forms that appear themselves as molds of bodies, slow accretions of material, and translucent skins verging on disappearance. What makes these objects cohere is a sense of memory, whether of familiar form or of some childhood association (something Rashid plays on with the titles he gives such objects as the humble garbage can, the Garbo). Such a sense of familiarity increases with as a sense of fleeting moments of the kind of artificial order that can arise from simple qualities as symmetry.9

So Rashid makes streamlined blobs in which the presence of the body shimmers at the surface of a fluid form about to dissolve into translucency. What makes all of this ultimately interesting is not so much the designer's savvy use of design history as the off-handed and purposefully prolific ways he turns such a background into mass-produced objects. Rashid does not design precious

icons or even complex mechanical objects. He has until now concentrated on housewares, furniture, and accessories. His work brings the reality of technology and the mechanisms of computer aided design to bear on the sorts of objects one might buy at Target.

Verging on the very edge of being disposable, Rashid's plastic chairs, computer mouse pads, perfume bottles, and shopping bags are finally fluid in the manner most sanctioned by our consumer society; they are meant to contain the flow of the most evanescent elements by which we build identity, from perfume to brand names to the sorts of tribal signs (like crosses and boomerangs) with which we decorate our often temporary homes. After all the translation of quantum physics into blobs and economic theory into ergonomic forms, it all comes down to this: Karim Rashid, shaman of identity, produces a fluid alchemy by which base existence turns from plastic into the fleeting embodiment of desire. Rashid's objects freeze, for a moment, not so much their own material or large and abstract forces, but our image of ourselves as consumable objects.

1. Cf. Peter Zellner, *Hybrid Architecture* (London: Thames & Hudson, 1999).
2. Greg Lynn, "Blobs," in *Folds, Bodies & Blobs* (Brussels: Books-by-Architects, 2000), pp. 157–67.
3. Ben van Berkel, Caroline Bos, *Move*, (Amsterdam: 010 Publishers, 1999).
4. Malcolm McCullough, *Abstracting Craft: The Practiced Digital Hand* (Cambridge, MA: The MIT Press, 1996), p. 98.
5. Ibid, p. 51.
6. Cf. Jeffrey Meikle, *Twentieth Century Limited: Industrial Design in America, 1925–1939* (Philadelphia: Temple University Press, 1979); Claude Lichtenstein, Franz Engler, eds., *Streamlined: A Metaphor for Progress* (Baden: Lars Mueller Publishers, n.d.).
7. For a current survey of the field, see Gavriel Salvendy, ed., *Handbook of Human Factors and Ergonomics* (New York: John Wiley & Sons, 1997).
8. Only recently have we come to realize the importance of plastic not only as a material that opened new ways of forming objects, storing material, and creating surfaces of an astounding variety, but also as a grounding metaphor for the malleability of our culture—in a positive, or at least neutral sense. See Stephen Fenichell, *Plastic, The Making of a Century* (New York: HarperCollings, 1997), and Jeffrey Meikle, *American Plastic: A Cultural History* (Rutgers: Rutgers University Press, 1995).
9. I discussed such qualities in my *Icons: Magnets of Meaning* (San Francisco: Chronicle Books, 1997), while Terry Riley focused on translucency in his *Lightness in Architecture* (New York: The Museum of Modern Art, 1997.

totem mouse pads, 1999

trivet trivets, Umbra, 2000 die-cast aluminum

cover for the National Design Triennial catalogue, **Design Culture Now**, 2000

concepts for Fiam, Italy, 1998 bent glass and chrome steel

kareames concept for a chair, Magis, Italy, 2001 injection-molded ABS plastic

ovaloid storage stool, Magis, Italy, 2001 original design 1997

kosmos champagne glasses, Ritzenhoff, Germany, 1999

semiramis hotel
Athens, Greece, 2001

» The beauty of the urban composite was no longer the image of the operative work-instrument, transforming itself and active, but became the final value,
» and in most cases an end in itself which made these centers objects of contemplation. —Gaetano Pesce

» In a product of beautiful art, we must become conscious that it is art and not nature, but yet the purposiveness
» in its form must seem to be as free from all constraint of arbitrary rules as if it were a product of mere nature.
» Immanuel Kant

>> To be is to Build. Martin Heidegger

>> what's important about these objects is that they are omni-directional, they're all slightly off balance, waiting to be manipulated—flexing

concepts for telephones, Sony, 1998

teleblob concept, Sony, 1998

seamless clock radio concept, Sony, 1998

seamless
concept for LCD travel clock / video player, P3 / Totem, USA, 1997 transparent silicon rubber, overmolded on chrome die-cast

concepts for minidisc player and compact disc player, Sony, 1998

teleblob concept, Sony, 1998

seamless clock radio concept, Sony, 1998

seamless
concept for LCD travel clock / video player, P3 / Totem, USA, 1997 transparent silicon rubber, overmolded on chrome die-cast

concepts for minidisc player and compact disc player, Sony, 1998

concept for clock radio, Sony, 1998

pulse mindisc player and compact disc writer, Sony, 1998

paola antonelli material boy

Pure energy and endless curiosity drive Karim Rashid in his restless exploration of materials and shapes. These characteristics, paired with the pure joy of being a designer, make him the paradigm of contemporary success. A mere synthesis of form and function has ceased to be satisfactory a long time ago. Beauty is a relative and ambiguous definition. The 1970s intellectual stratagems—for instance the assumption that feelings and emotions are actually functions themselves—do not seem to work any longer, either. In our demanding present, we are looking for meaningful objects that can make a synthesis of it all. The best contemporary objects are those which express consciousness by showing the reasons why they were made, the process that led to their making, and their place in the world.

Knowing the material world is the path to contemporary design. Rashid displays a masterful command of manufacturing techniques and materials and can keep the function assuaged and the unit cost low while achieving a distinctive new shape. This brief paragraph describes the necessary basic ingredients for a good design recipe. The chef's hand, in the end, is what makes it into a tasty and unforgettable dish.

Designers face today the multiple challenge of a need for old-fashioned economy of design—of means and goals, in order to achieve sensible retail prices, satisfactory product lifecycles, and adequate socio-environmental precautions; and at the same time the need to interpret the complexity of a multifaceted and sophisticated public, who expects objects to make connections among them and with the rest of the world. The omnivorous Rashid, who has moved swiftly from fashion and music to industrial design and small series, has the advantage of flexibility built into his own nature. Today, technology offers designers a new exhilarating freedom of both inspiration—the whole world is available on the media and reachable by plane—and manufacture. Inspired by a humanity undergoing quick change and evolution, Rashid finds new ways to address the myriad issues that design can master, and appropriates new areas of intervention as he goes.

Rashid matured as a designer at a time of profound changes in design and in the world at large. Our perspec-

22one watch, Umbra, Canada, 2000

concepts for watches, Yahoo!, 2000

tive on the material world has evolved dramatically during the past ten years, so deeply as to visibly affect even areas that are traditionally resistant to ethical tidal waves, such as fashion and popular culture. After the sensorial and material overdrive of the Eighties, the jaded inhabitants of the Western Hemisphere seemed ready for a new obsession, this time with simplicity and purity. The new code of action in the field of design was best symbolized by Droog Design (or "dry design"), the Dutch movement which first appeared in 1993 and which celebrates a brand of ingenuity and economy which has been transformed into a coherent minimalist aesthetic.

Dutch design of the mid-nineties also revealed the emergence of a new balance between technology and artifacts that to this day has enabled such a systemic revolution. All over the world, contemporary design does not glorify advanced technology in the way it did during the 1980s, but rather it appreciates technology for its ability to simplify and/or enrich our visual and material landscape. In other words, for how it can simplify our lives by making objects lighter, smaller, and less formally obtrusive, as well as less onerous on the environment. We have come to think that beauty is all in the intention, the novelty, the composition, and the attitude, certainly not in such a reductive concept as formal homogeneity. The emancipation from the old-fashioned concept of unique beauty is one of the biggest achievements of this century. Beauty is today a matter of composition and personality, in urban fashion, design, and architecture alike. Hip-hop music, based as it is on sampling and composing new and pre-existing tracks and giving them a finishing varnish of surprising novelty, is the paradigm recipe for contemporary beauty, which is based on synthesis and individual talent.

Moreover, very high technology can today coexist in a peaceful synergy with very low technology, as Rashid's oeuvre exemplifies. New technologies are being used to customize, extend, and modify the physical properties of materials, and to invent new ones endowed with the power of change. New materials can be bent and transformed by engineers and by designers themselves to achieve the design goals that they have in mind.

Materials have become curiously deceptive and sensitive to the designer's intentions. But the tools to work them to the final shape might not yet exist. Some advanced materials actually demand manual intervention, while

concepts for watches, Cosmoda, Canada, 2000

some low-tech materials, like glass milk bottles, merely demand a crafts approach because of their essential nature. Experimentation, be it high- or low-tech, requires a hands-on approach, and the flexibility and novelty of the materials and manufacturing methods available today has stimulated the exploration of numerous possibilities. In this lively and innovative scene, materials—whether recyclable, reusable, durable, or biodegradable—have acquired a different role in the design process. Instead of being mere tools, they inform and guide it.

Under these circumstances, the relationship between the designer and the manufacturer is crucial. Rashid tends to take a proactive role and involve the manufacturers in his quest for new, sensible ways to achieve contemporary beauty in design. He was the one to propose to Nambe, the well-established manufacturer of objects made of a secret-recipe alloy of metals and identified with the 1950s, new computer techniques to produce shapes that seemed once impossible to achieve. When a new Canadian company that produced a special sandwich of glass and PMMA sheets, the basis of Rashid's Aura table, closed its doors, he shopped variations of the technique around the world, until he was able to find the right recipient.

Rashid belongs to a very contemporary group of designers whose elective mission is to endow objects with a communicative soul. Curiously, the way to reach this transcendental state is through a dive in the most physical world of materials and techniques and in ancient inspiration. The shape of Megan Lang's—Rashid's wife—body has inspired sofas, containers, and chairs. Rashid's technological expressionism represents the last frontier of modern design, and even his most advanced products seem to carry the touch of a hand, or the imprint of a shoulder.

Shmoo is a high-heeled sneaker for women with built in G.P.S. and Biofeedback Monitor. The biofeedback monitor updates your health status, measuring blood pressure, blood sugar, heart rate, and stress levels. Biofeedback and positioning information is displayed on L.C.D. incorporated into the upper surface of shoes. The sole of the shoe is a composite, of self-healing and deformable plastics, which react and adapt to road conditions. Sensors located under the sole will determine optimal conditions for maximum grip, control, and support as required. The rectangular aperture in the sole functions as shock absorber, and a hot swappable access port for the Sole Camera and all other electronic units. The rounded aperture above the ankle at the top of the shoe is an expansion port for upgrades such as MP3 player, acu-pressure massager, medical and training aids. A video/still camera is installed at the rear of the shoe. Images can be viewed while training either on the shoes themselves, on an eyewear mounted display, or later on a plug-in monitor.

shmoo shoes, designed for an exhibition at SFMOMA, 2000

Oishii Restaurant

Steven Starr, Philadelphia, 2000

karim imagos tattoo, Megan Lang, 1999

cross concept for carpet, Directional, USA, 2000

speedmeter wool carpet, Directional, USA, 2000

cool glass, Ritzenhoff, Germany, 2000

karim imagos pens, ACME Studio, Hawaii, 2000

CROSS concept for carpet, Directional, USA, 2000

kwilt concepts for thirty-seven carpets, Directional USA, 2000

porno graphic light-emitting polymer, Duraflex, 18 x 90", Sandra Gering Gallery, 2000

KarimFlage digital painting, Totoem, USA, 1998

» Work is love & Love is work. Megan Lang

greeting cards, Totem, USA, 2000

semiramis hotel restaurant, Athens, Greece, 2001

octopus silicon tiles, Germany, 1999

ashtrays, Ritzenhoff, Germany, 2000

opposite page: **morphscape** special edition laminate, Wilsonart, 1999

landscape cafe Philadelphia, 2001

kitchen design, New York, 2000

totem store interior, New York, 2000

morphscape concepts for laminate furniture, 2000

global energy manhole cover, Con Edison, USA, 1999 cast iron

gyro clock, Umbra, Canada, 1996 (design 1989) aluminum with chrome hands

Karim Rashid at home, New York, 2000

Karim Rashid, Inc., New York, 2000

FloGlo 1 & 2 chairs, IDEE, Japan, 1997 chrome legs, high-gloss lacquered sheet steel, gloss white outside, fluorescent inside

pauper hat, North, Canada, 1991 formed wool and felt

arp barstools, Pure Design, 1996 chrome and steel legs with bent plywood seats

x-hat hat, Babel, Canada, 1988

electrolyte lamp/shelf unit, IDEE, Japan, 1997
high-gloss lacquered steel, one side gloss white and other side fluorescent

lexicon coffee table, IDEE, Japan, 1997
chrome legs, high-gloss lacquered steel, gloss white outside with fluorescent inside

light heat-sensitive table, Totem, USA, 2000

light II heat-sensitive table, Zanotta, Italy, 2000

aura coffee table, Zeritalia, 1997 metal frame with shaped 12mm glass sheets colored with water-based paints (Colorglass System)

kelly rude immateriality

In a 1997 exhibition at Tokyo's Idée Gallery where Karim exhibited a collection of furniture, the designer "endeavored to speak about immateriality." How does one address immateriality in a material way? Dare one say that there are spiritual trends? Current furniture companies are sporting names like "Kundalini" and "Plastic Buddha."

New age spirituality was rife at the end of the last century and the practice has gained speed at the beginning of this one. Multiculturalism has created a pluralistic hegemony, and design, even in all of its aberrations, is the current multicultural transmitter.

My review of the Idée exhibition for Toronto's *Azure* magazine concluded with the following: "Can contemporary design touch the soul? It can at least engage the viewer in a study of guided meditation." I was referring specifically to Rashid's deployment of Day-glo colors and his use and placement of graphic cutouts on the backs of chairs. A signature shape of the Egyptian-born, North American-educated designer, is the roman cross.

In a chapter entitled "The Purpose of Clothes," from *The Beauty of Islamic Dress*, compiled by Rashid Ahmed Diwan (no relation to Karim; Rashid is a common Muslim name): "It is not permissible to wear a neck tie. A neck tie is the symbol of the Christian cross. It was designed by the Christian world as a sign of the cross symbolizing Jesus's alleged crucifixion. The practice of the neck tie started at the insistence of the Pope in 1790."

Given this (all be it an historically questionable) reference, one can imagine the indignation of Karim's father, when he discovered his son sporting a roman cross tattooed on his right arm. It may be said, though, that symbols are only as potent as the meaning we give them.

I personally covet Buddhist and Hindu images and effigies that contain the swastika, often positioned on the heart, or on the arms of chairs. (Regardless of which visual meditation practice one follows, there is some consistency about the left side of the body as receiver of energy; the right side, the sender; and that these energies cross at the area of the third eye; hence the swastika outline.)

In the body posturing of meditation practices based on visualization (Hindu, Tibetan Buddhism), *chakras*, or

oblong table, IDEE, Japan, 1997 steel chrome frame with lacquered wood

energy centers, become real over time. Innerself becomes a tangible reality. The body becomes conscious of its displacement of space. Enlightened beings have halos. Rashid's Day-glo/cutout furniture forms address these issues and punctuate the narrative with yet more graphic symbols to draw one into this desire for transcendence. His placement of the roman cross cut out on the chair back is in close proximity to the location of the heart chakra on the human body when seated on the chair, and his juxtaposition of an oval behind the cross brings to mind the Sufi reference of "the hole at the back of the heart."

Day-glo (and black light) have had interesting careers. There is a twenty-first-century tune in the combination of Day-glo and white. Rashid has also rendered this color combination in rubber accessories in the shape of a figure eight, another symbol he has made extensive use of, widely held to be the symbol of infinity. Join the ends of a swastika, gently curve the lines, and presto: a figure eight.

Rashid's "Oh" chair for Umbra was originally to be called the "Ohm" chair. Also spelled "Aum," the Hindu Sanskrit vibrational sound may indeed be the root of the Christian chant amen and the Islamic amin.

Rashid's new Softscape, a digital 3-D rendering of a lunarlike surface is very sci-fi. Science fiction and spirituality are a lot closer than many would like to believe. In fact, several new religions refer to Yahweh (loosely translated from the original Hebrew of the Old Testament to mean God) as actually meaning, "Those who come from the sky." Cultures like the Mayans were steeped in their worship of the cosmos, and religions like Islam consciously follow the sun and moon in their prayer rituals. The moon, according to the Sahaja Yoga tradition, rules the ego.

Some see this use of symbology in the twenty-first century to be simple expressions of "pop" culture, and the titles of Rashid works: i.e., Ecstasy of the Unnatural and Addition by Subtraction as merely the marketing of product as concept.

One should not underestimate the importance of this so-called "pop" culture. I actually believe the Rashid narrative. As best as I can decode it. Or project myself on it.

Call it post-design rationalization. But the deeper I delve, and the more I read into Rashid's work, the more centered I become. It's not surprising that Ettore Sottsass referred to Karim as being as much an artist as a designer.

moray glass table, IDEE, Japan, 1997 steel chrome with solar chrome striped glass

emporio armani

design of flagship store, New York, 2000

karim rashid

Today the development of products, furniture, and lighting is based on important criteria: human experience, social and global issues, economic and political issues, physical and mental interaction, form, imagination, and a rigorous understanding of contemporary culture.

Our EXPERIENCES are becoming less apparent, and products around us have taken on a banality and a certain sameness due to mass-production, lack of funds or interest, low-capital investments, and the great mass mechanization of the twentieth century. The RESULT is few ideas and many variations.

Today industrial design is changing and the role of designers is plagued by either not being necessary in a knock-off marketplace or by being involved only on a surface or "skin" level of objects. Whereas our involvement, instead of being instrumental, is to design product that only deals on a predominately visual level. Our involvement must be In the mnemonic stage of development, in con-

the old school new school mix

ceiving ideas and playing a rigorous role at defining the object's value, performance, and intelligible existence. In turn, Industrial Design must become more visible in a world of media so that design is of pedestrian interest and desire rather than a marginal subject. The greater the awareness, the more the need for our participation.

Design has attempted to embrace ideas of interaction, man-machine interface, meaning, and language. Yet, the excess of products that continually emulate an already exhaustive situation tends to continue at an even greater speed allowing even less involvement in the development of these products.

I would like to discuss new theoretical approaches applied to the object in the new society and address Industrial Design as a confused profession. Design encompasses a political and social role. The hyper-explosive period of the twenty-first century is the advent for a critical stance and a celebration of the object and its interjection to an "immaterial" infinity. Traditional empoison of design methodology and a globalization of the consumer product brought end to the "modern" language of the object. Yet objects have become endless appropriations of one another, a cloning of clones as we trade spiritual values for material values and originality for simulation.

In the late eighties, while objects, especially furnishings, were in their maturity of the "high design movement," we witnessed in theoretical circles little discourse on the new ways of informing physical objects. In Industrial Design, theory hardly exists, unlike Architecture and Art, which in the last decade embraced discussions on immateriality, ambiguity, hybridization, post-structuralism, representation, simulacra, phenomenology, feminism, semantics, deconstruction, postmodern condition, tribalism, etc. The Industrial Design rhetoric "that design is no longer strictly about things or objects" became the controversial argument. This was a way or rubric as a point of entry into finding new direction in design: a new pedagogy.

Schools began to concentrate on object as meaning, using simile, representation, metaphors, symbolism, and even remote circumstantial narratives to inform objects. Imagery was the worst case. For example in his book *The Meanings of Modern Design*, Peter Dormer, a designer, was asked to design a new hair dryer. The designer informed his project with words such as "wind" or "air." In turn, the word air is a reference to birds and the hair dryer

new move glassware, Leonardo, 1999

form becomes winglike inspired by a peacock. I am not sure how peacock entered the discussion. The result is a fan of a different form. Is this the ideology we must engage to find new forms, or is there really any need to find new forms, but instead to design projects that consist of existing language? Syntax became the inspiration for form. Another perfect example is the literal fantasy of objects by Guy Dyas such as his Vacman Vacuum. The concurrence of such searching, as we saw in many design schools resulted in a few original results and a morass of objects that had little to do with their respective subject. Generally the syntax of simile produced a new form of embellishment, a way of decorating objects that could never really be explained to the consumer. Sometimes the result is very literal and we end up with objects that border on kitsch.

The form-follows-function discussion—a banality in itself, is completely irrelevant when it comes to sophisticated products with such complex subjects, digital componentry, almost mythological hyper-objects that engage little interaction, if any. So how do we shape these objects? A return to the subject is the origin of discussion and a place to study meaning and myth. Inanimate objects do not have meaning. We project meaning on objects. Without sounding too pedantic, in the nineties I believe that design is the study of the subject that informs the object. Form follows subject.

The point is that subject is not necessarily necessity driven or an issue of function. Subject may be a philosophical position on contemporary culture, a tenet, an odium on a condition. A subject may be human experience, gathering, behavior, movement, cultural phenomena, media, flexibility, sustainability, variation, reconfigurability, immateriality, materiality, consumption, transparency, digital production, etc. Perhaps the subject is erroneously banal such as "reusing existing tooling" or tooling modification. These issues constitute a language based on dealing with the subject and not the object. This is the First Order of design.

The study of objects can be investigated and by the study of Typology—meaningful identities, modes, types,

postures, and categories; Morphology—formal articulation spatial boundaries; Topology—spatial order proximity, continuity, organization; and Context or Telelogy—environment, market, dissemination, distribution, and visibility. The design process is one of marking time with works that become a platform or foundation for other works via the continuum of concept from subject.

Can design transcend its past and become a subject or methodology for commentary or self-expression? Can we expect from product design an actual commentary on culture, on social issues, or a message? Or is design relegated to serving purpose, to fulfill needs only, to create a more comfortable, convenient situation or condition? We realize that commodity is dangerous in as far as the proliferation and hyper consumption of it. At the same time objects shape our everyday lives, as we perpetually interact with them at every moment of our lives. For every object that is placed on the market today it should replace three objects. This is good design.

We are amidst a post-industrial age, an age where autonomy, diversity, change, vicissitude, and the moment exist in harmony with technological manifestation. The past is pointless yet there is a great deal to learn from it. One must learn everything about history and then forget it all. In order to make change in the world one must understand where the world is going and create the change from within a given contemporary condition, not resort to a condition that is misanthropic and historic. The Old school spoke of Industrial Design where industry and technological production worked hand-in-hand and the machine dictated the limitations of production process. Sotsass said in 1982 that we are entering a time when we control the machine, the machine does not control the outcome. Few designers embrace technological process. It's almost to the point where designers are acting as naive artisans who want to 'self express' regardless of manufacturing. If Industrial design must mature into the new digital transformation. The process of Design is to develop very intelligent solutions with new ideas to manifest our objects of our milieu. If we can embrace the Old School concerns of total engagement in production and Industry we produce responsible objects. If we can achieve the newer issues of responding to the subject at hand and develop highly experiential, communicative, interactive but poetic works, then good design can exist respectfully, visibly, and effectively in our commodity landscape.

new move: boom glassware, Leonardo, 1999

new move: reflex glassware, Leonardo, 1999

» You've always got to do what you don't know. glen cummings

soft pendant lamps, George Kovacs Lighting, USA, 1999 Murano tinted glass with chrome, from the Soft Collection

shimmer candlesticks, Nambé, USA, 1994 polished metal alloy

soft floor lamps, George Kovacs Lighting, USA, 1999
Murano tinted glass with chrome, sixteen different lamps created by four forms

concepts for gin and tonic and martini glass,
Bombay Sapphire, 2000

shroom table lamp, George Kovacs Lighting, USA, 1999 cased Murano glass, chrome Each piece of glass is random; no two are alike

garbo five-gallon trash can, Umbra, Canada, 1996 high-impact polypropylene

eugenio perazza — edgeless

Pochi mesi fa in un supermercato di una piccola cittadina del Veneto ho comperato un tavolino da esterni e ho speso 30.000 lire (15 dollari).
Una base in pressofusione di alluminio, un tubo di alluminio ed un piano in acciaio inox spazzolato, diametro 60 cm.
Made in China.
Onesta la qualità del design, discreta la qualità costruttiva.
Penso che il costo ex-factory sia di 7500 lire (3,75dollari).
Osservazione: se questo prodotto venisse realizzato in Italia 7.500 lire (3,75 dollari) non sarebbero sufficienti a coprire il costo dei materiali diretti.

Ecco quindi entrare in gioco il design.

Il design come valore aggiunto che deve aiutare le aziende ad uscire dalla mischia per cercare propri originali percorsi, tanto più oggi che il mercato è globalizzato.

Il design al centro del progetto.

Il design che non è l'esercizio di stile ma è il motore del progetto stesso che spinge l'azienda a varcare nuovi orizzonti formali, nuove tipologie di prodotto e nuove tecnologie.
Ma non basta.

Se è pur vero che la tecnologia è disponibile sul mercato, peraltro, la tecnica, intesa come la capacità di far funzionare la tecnologia, non lo è, perché è capitale intellettuale proprio ed esclusivo dell'azienda.
Ed è qui soprattutto che si gioca la sfida futura tra mercato e mercato, tra azienda e azienda: nella tecnica e nel design, nel saper mixare bene questi fattori per creare alla fine il progetto vincente sul mercato.

A few months ago in a shop in a small town in the Veneto, I bought an outdoor table for 30.000 lire (about $15.00).
A die-cast aluminium base, an aluminium tube, and a stainless steel aluminum top, approximately sixty centimeters in diameter.
Made in China.
Honest kind of design, discrete building quality. The production cost should be about 7.500lire (about $3.75).
Now, if this item were to be made in Italy, 7.500 lire would not be sufficient to cover the cost of the materials.
Here came the role of the design.
The design as added value has to aid companies to move out from the fray in order to find out its own original links, now that we are so fully immersed in the global economy.
Design is now at the center of the project.
Design is not a style exercise, but is the motor of the project, allowing the company to move towards new aesthetic horizons, new production typologies, and new technologies.
But even this is not enough.
If it is true the technology is available on the market, on the contrary technique, wich is the capacity to make the technology work, is not, since technique is the exclusive intellectual capital of the company.
Here is the future challenge between market and market, between company and company: technique and design, bringing them together in order to create a winning project for the market.

» We are up against this contrast between a design utterly void of any meaning — with a glut of forms and functions kept alive by a production sphere plagued with excess.
» Maurizio Morgantini

klean dish rack, Guzzini, 1999 polypropylene

jeffrey deitch

shroom stools, IDEE, Japan, 1997 vinyl upholstery

shaping the esthetic economy

If there is one person at the nexus of the current convergence of art, design, entertainment, and business, it is Karim Rashid. As a curator and gallery director, I am always searching for artists who don't just make good-looking objects, but who expand the definition of art. As a thinker, object maker, entrepreneur, and communicator, Karim Rashid is expanding the scope of design.

One of the most exciting developments in contemporary culture is the deliberate blurring of the borders between art, design, fashion, entertainment, journalism, advertising, and business. The modernist distinction between vanguard and mainstream culture is progressively dissolving. The juxtaposition between the high and the low that enlivened the modern approach is being replaced by a seamless esthetic economy where innovative design and new modes of visual communication permeate everyday experience. Integration rather than separation of media characterizes this new direction.

This seamless approach also characterizes Karim Rashid's work. His designs flow organically, fusing the material with the form. His formal language reflects his philosophical vision. Edges dissolve and functions merge. If the twenty-first century does become the era of biotechnology, Karim Rashid will be helping to define its look. He uses materials that allow his forms to flow like the body, echoing life forms rather than abstract orderly structures. Like so much in contemporary life, his forms are more irrational than rational. Rather than form following function, form stimulates function.

Design for Karim Rashid is neither an esthetic preserve nor a service business. It is an economic and cultural engine that propels growth and transforms life experience. Design is not about supporting a marketing campaign, but about entrepreneurs. Business development and communication of the design concept are an integral part of Rahsid's approach. In the 1970s, Andy Warhol declared that Business Art was the best art. Many of us wanted to embrace his idea, but frankly didn't really know what business art was. It took some time, but the business artist is now here. One of the first is Karim Rashid.

oh Fizz chair, Umbra, 1999 injection-molded polypropylene with powder-coated steel tube legs and casters

14.475

oh chair, Umbra, Canada, 1999 translucent injection-molded polypropylene with powder-coated steel tube legs

N. Rain Noe interviews Karim Rashid, New York, 2000

>>

>> N. Rain Noe: *Let's talk about product design.*

>> Karim Rashid: Did you know that people touch, on average, 500 things a
>> day—opening a door, putting on a ring, using a phone, drinking from a
>> glass/can/bottle, etc.?

>> And yet, with consumption, experiences have changed. Look at Christmas, the
>> number one consumed item last year in the US was video games, number two
>> was music, and number three was Hollywood films. That's all immaterial, and
>> we are consuming those things because now those are the things giving us
>> experiences, whereas in the past it was a wooden toy or clothing or
>> something else. So how do you bring objects to the level of film, or the
>> level of music? How do you make them as poetic and as powerful in daily
>> life as those things are? That's my agenda.

>> NRN: *What are some of the elements of the Karim Rashid plan? What types of*
>> *things do you design and would you like to design?*

>> KR: I only want to do things that are very much a part of everyday life,
>> part of popular culture. Industrial design is a broad field; you can do
>> anything from aerospace to ceramics. What I want to produce are objects that
>> are very sensual, very tactile, things that are a part of our contemporary
>> popular imagination, things that create our experiences.

>>>> The bigger plan is to design and actually produce a lot of products that are
>> really, really accessible, that you would find anywhere and everywhere, that
>> really adds to people's lives, whether it be furniture, or spaces, or

>> table-top things, or lighting, or high-tech products.
>> I'd also like to bring to American culture a more mainstream acceptance of
>> design, so that it isn't fringe. Design in the last five years has changed a
>> lot in the U.S.; there's this new awareness of the medium. There's this idea
>> of democratic design, design for everybody. Americans have never really
>> embraced or celebrated design at all, so part of my agenda is to try to
>> engage that.
>> And I'd like to spread the design gospel—that this stuff is motivational and
>> inspirational in our lives. If you're going to have things in your life,
>> they might as well bring some level of pleasure to you, or you shouldn't
>> have them at all.

NRN: *Can you elaborate on that?*
KR: I have a kind of "immaterial material" philosophy, a kind of reductive
>> philosophy: if you are going to have things in your life, they should be
>> additives, they should be bringing you something. They shouldn't be
>> obstacles or subtractive. If they're obstacles in our lives, then why hang
>> on to them?

NRN: *As you said before, industrial design is a broad field. What are some of*
>> *the product categories and clients you've worked with recently?*
KR: Cosmetics [packaging containers] for Tommy Hilfiger, Prescriptives,
>> Ralph Lauren, Estee Lauder, Issey Miyake, Prada and others. Furniture, for
>> Italian companies like Magis and Edra, Japanese companies like Idée, French
>> companies, Canadian companies, and a company in Mexico. And I'm doing a lot
>> of high-tech stuff. I just finished some product for Sony.

NRN: *Can you tell us what that is?*
KR: Not 'till it's out. Well—it's a boom box, and other objects. I can say
>> that. I'm also working with a new start-up company called P3. We're gonna do
>> some really outrageous CD and MD players. I want to break The Wiz paradigm;
>> The boom box culture is so weird, the stuff is so ugly, I don't know where
>> all that language is coming from! They're really Darth-Vader-looking,
>> they're really dated. Or this alien, Oakley [the sunglass company] language.

NRN: *What aesthetic would you prefer?*
KR: I want to do some things that are really poetic, very minimal, tactile,
>> with new materials. I'm very interested in new materials and new
>> technologies, and there's a kind of digital aesthetic to my work.

EC: *What do you think about MP3 players—the whole not having a tape or*

ya table, Umbra, 2000 injection-molded polypropylene with powder-coated steel tube legs

bibowl bowl, Umbra, Canada, 1999 injection-molded Cleartint® polypropylene

>> cassette thing?
>> KR: I love it. The idea of having something that has no moving parts is
>> completely flawless, amazing. Since music can now be stored, and traveled
>> with, as zeros and ones, I think it makes sense that the thing becomes as
>> immaterial as possible. No gears, nothing that moves around.
>>
>> NRN: That's such an ironic thing for a product designer to say! Because things
>> like mp3 are moving toward the disappearance of the object altogether.
>> KR: Good! If every object disappeared tomorrow, I'd be happy. I think that
>> we need to dematerialize, period. The world has way too much stuff in it.
>>
>> NRN: How can a product designer–a person whose very job is to design more
>> objects–contribute to dematerialization?
>> KR: Where a designer can contribute is to be smart about those things, to
>> encourage clients to downsize. To tell a company, "Look, you make 600
>> things, why don't we make just 30 decent things. And maybe you can still
>> feed 200 families with your company." That kind of product downsizing. What
>> if we could produce less, but have heightened experiences with those fewer
>> objects? We could have more value with less.
>>
>> NRN: So would you consider yourself more of an Experiences Designer, rather
>> than an actual Product Designer?
>> KR: That's a good one, I like that. I always call myself a cultural editor,
>> an object shaper. Product design is a weird term because it's like I don't
>> want to design only products. I want to do everything. Designers and artists
>> will become cultural editors, or cultural engineers and "business
>> strategists of culture. The design trend will be more pluralist. Design
>> will be based on offering corporations originality and ideas that deal with
>> contemporary issues, phenomenals, and culturally relevant proposals. Today
>> there are few ideas, and many variations. Me-tooism as a business strategy is
>> over. Businesses must differentiate themselves and innovate. Design and
>> production will play critical roles in leading companies into new
>> directions, and new opportunities.
>>
>> A designer will be a cultural purveyor and Developing products that people
>> want to elevate experiences, developing proposals that actually really
>> change our lives and bring a heightened more enjoyable experience to life.

bisor hat, North Studio, Canada, 1991 melton wool

L'EAU D'ISSEY POUR HOMME

EAU DE TOILETTE POUR L'ETE
SUMMER EAU DE TOILETTE

ISSEY MIYAKE

>> Artists will have the same affect.
>> NRN: What else are you working on?
>> KR: I'm doing two hotels right now, two fashion boutiques, an art gallery, and a restaurant. I'm working on a clothing concept for about a year from now. I'm expanding.
>> NRN: Into territories that traditionally have not been occupied by industrial designers.
>> KR: In this day and age, it's more interesting to have this cross-pollination of professions. You see architects doing clothing, or fashion designers doing furniture. DJs doing art shows. There's a lot of shifting around. You get a different kid of perspective on stuff, a very different attitude. We're living in a day and age now where if the ideas are good, if you're disseminating interesting things and information, it really doesn't matter what your background is. I would argue that media is complex today, multi-layered, prodigious, and it is not dumbing us down. The realms of info and infoaction have "educated" the uneducated and technology is democratizing a new global culture. We are more informed, we write more, we have greater choice, we are becoming savvier. We expect more. We are more critical, more discerning, and participatory.
>> NRN: Do you think that that's true, even on a street level?
>> KR: Absolutely. As an example—all of a sudden you see kids with no education in graphic design, doing very beautiful rave fliers on their Macs. You see entire books published about these rave fliers.
>> You start to realize that the only way to be good at anything is to have original thought and original ideas. It really doesn't matter what your education is. And thats realizing that will allow people to do what they are actually interested in. At one time, I think a lot of people went to school not knowing what they really liked, but now there's more to an awareness about what's out there, and what the possibilities are. You can make choices at a younger age to enjoy and live the life you want to live versus taking a nine-to-five job because you didn't dare to become an actor.
>> NRN: Speaking of which, how did you decide to get into design?
>> KR: When I was growing up, my father [a painter and set designer for TV/film] built and designed all our furniture, and he designed all of my mother's dresses. So he inspired in me the notion that you can just create packaging and new bottle finish and color for 100ml L'eau d'Issey Mens' Summer Fragrance, BPI Parfumes / Issey Miyake, 2000

jambo tray, Umbra, Canada, 1999 injection-molded Cleartint® polypropylene

>> anything you really want. I think I was destined to do this.
>> NRN: *I understand you worked/studied in both Canada and Italy. How did you get started in the 'States?*
>> KR: I left [my job as partner of a Canadian design firm] in 1991 because the Canadian economy was awful at the time, we had really boring clients, and I felt that I was wasting my life. After that I got a full-time teaching job at RISD, a three-year stint. They fired me because they said I was too theoretical, too controversial. So I left RISD, went off to New York and found a job at Pratt Institute. Fortunately—if I didn't, then I wouldn't have been able to get a visa to stay here. At that time I also started my firm, around seven years ago.
>> NRN: *I remember in the early days (7 years ago), it was just you and a couple of assistants. Now there's a bunch of people running around all over the office. What direction is all of this going in?*
>> KR: My staff are great, sometimes confused because of my pluralist obsessions from art to architecture to fashion to objects. I want to write, to film, to make music, and do one creative project after another—to share globally. This is difficult for the majority of people: some find some of these disciplines superficial, I find that all this shapes our world, our behaviors, our being and our psyche. I love the energy of our existence, and of making change, I really want to change the whole world. I now have [in addition to a staff of industrial designers] an engineering staff, an architect, a graphic designer, and I want to formulate a factory, an almost Warholian factory of design, but design as ideas. Wherever those ideas take me. So if it's an idea to publish a magazine, or an idea about music or whatever, then I can do that. My [eventual goal is that every time I want to do something, that I can do it.
>> That will be based on two things: One, it's based on the economy, you have to have patrons or people have to buy your stuff. That's the hardest part. Two is just time. How do you manage to do all that? I think you manage by good cooperation, meeting the right people, and doing the right thing.
>> EC: *Now for the standard "artiste" questions. From what do you draw inspiration?*
>> KR: Inspiration is an interesting thing… I think inspiration for me is an accumulation of all my experiences. I travel a lot, like reading and absorbing. Music inspires me to a great deal. I love the art world; I'm

stash magazine holder, Umbra, Canada, 1998 injection-molded metallic polypropylene

kases

Issey Miyake, 1997 stamped flat sheet polyethylene and metallic static shielding bag

>> obsessed with it, so I see a lot of shows and things. Movies as well. I
>> think all those things are my inspiration... you can't say it's exactly from
>> here or exactly from there.
>>
>> NRN: *Any thoughts on American culture?*
>> KR: I think this culture in America is really fucked up slash very, very
>> inspiring at the same time. It's amazing that a country so powerful is, on
>> one hand, as liberal is it is, and on the other hand so completely backward
>> and conservative. Like we live in some kind of contradictory phenomenon. You
>> can use words on TV like "bitch" and "dildo," which is amazing, and yet at the
>> same time you cannot show any nudity. We're the number one exporters of
>> pornography in the world and yet at the same time we can't have nude beaches.
>> That's the hypocrisy. We own the operating systems for the entire world and yet
>> we don't have HDTV yet. You know? The cell phone structure in this country is so
>> backward, and yet we write the majority of the software in the world. It's very weird.
>>
>> NRN: *Why America, and why NYC for your studio?*
>> KR: First of all, there's sixteen people in here, and only one person is
>> American. I think the only place I could do that in the world would be NYC.
>> Number two is that nobody here cares about race or creed or any of those
>> things. Here, I don't get people asking me "Oh, are you Pakistani?" or "Are
>> you English, Indian, Canadian ?" or "Are you Egyptian?" etc. Nobody really
>> cares. The fact is that if you're good, and you do good work, you're good period.
>> In most cities, politics and race start to lay the first role. When I was in
>> Milan, the fact that I'm not Italian would be an issue. I lived there and I
>> know it. So where else are you gonna be in the world, if you want to feel
>> really free and liberal and really multicultural?
>> I love the idea that in this office I've got Japanese, I've got Germans,
>> Spaniards, Italians, Russians. Fuck, every time I get published in a foreign
>> magazine, someone can read it to me! I love every part of the world. I feel
>> every part of the world.
>>
>> NRN: *Anything else you'd like to tell our readers?*
>> KR: The thing I'd like to tell the readers is, to open your eyes to this
>> physical world we live in, and embrace it, and enjoy it. And when you
>> consume, think about what you consume. Consume something because it's a
>> beautiful thing or because you really enjoy it, don't consume because you've
>> been brainwashed by a brand. Don't consume for the sake of consumption. Say
>> "is it going to add something to my life?"

tribowl bowl, Umbra, Canada, 1999 injection-molded polypropylene

Laziness is the anti-Christ.

rim bowl, Umbra, Canada, 1999 injection-molded polypropylene with polished finish

garbonzo trash can, Umbra, Canada, 1996

pod container, Issey Miyake, 1997 injection-molded polypropylene and metallic static shielding bag

2-in-1 travel kit

L'eau D'Issey Pour Hommes, eau de toilette and alcohol-free deodorant, BPI Perfumes / Issey Miyake, 1999

ribbon desktop landscape, Totem, USA, 1999 PVC

infinity and soul desktop landscapes, Totem, USA, 1999 PVC

hand-hand bag, Issey Miyake, 1997 flat polypropylene sheet with injection PP handle

spine bag, Issey Miyake, Japan, 1997 flat polypropylene sheet with silver nylon strap

torso bag, Issey Miyake, Japan, 1997
flat polypropylene sheet with injection polyolefin handle

bust bag, Issey Miyake, Japan, 1997 flat polypropylene sheet with handle

new bottle design and travel case for 100ml L'eau d'Issey summer Fragrance, BPI Perfumes / Issey Miyake, Paris, 1999

packaging for 50ml L'eau d'Issey eau de toilette, BPI Perfumes / Issey Miyake, France, 1999 polypropylene with living hinge

bow and tummy

holiday bags, Issey Miyake, Japan, 1997 extruded polypropylene sheet, same pattern creates two different shapes

concept for perfume packaging, Prescriptives Balance Collection, USA, 1999

concept for packaging duty-free L'eau d'Issey, Issey Miyake, France, 2001

concept for digital camera, Sony, Japan, 1997

Father's Day Kit, Issey Miyake, France, 2001

issey in your pocket packaging L'eau d'Issey, Issey Miyake, France, 2001

concept for perfume packaging, Estée Lauder, USA, 1999

concept for perfume packaging, Prescriptives Balance Collection, USA, 1999

>> It's so hard to have a good time.
>> Frankinfurter, Rocky Horror picture show

Digital Nature Exhibition, Tokyo Go Building, 1996

butterfly chair, Magis, 2000

loop chairs and table, IDEE, 1996 powder-coated steel tube with vinyl spaghetti cording

karim rashid **pleasure**

After ten years of practicing I hated industrial design. I remember wanting to leave the profession, having a greater interest in art and fashion because these professions seemed more liberated. These professions were intellectual but fun, exciting and full of energy and life. Experimentation was expected. Strong personality in the work was obvious. As with art I realized that in the underlying agenda of the fickleness of fashion, life, time, and space were being defined, being documented, and being tried and tested perpetually. They optimized autonomy of expression, of contributing to the ever-changing, ever-vast cultural shaping of the world and popular culture. I knew that industrial design could play the same, if not, even more profound role. All culture is now popular and I wanted

loop chairs, IDEE Japan, 1996 powder-coated steel tube with neoprene wrapped for seating and back

to participate in it. I wanted to create beauty, relevant objects to our new global nomadic lifestyles. I wanted to engage the new digital global marketplace and I also realized a few years ago, after playing it safe for the longest time, working with many conservative dull clients. I remember fifteen years ago proposing a colored, new, clear-tint polypropylene to a kitchen appliance manufacturer, and the reaction was, why would anyone want to have a translucent appliance? I remember presenting a humidifier that was an organic simple translucent object with no visible interface, and tall and vertical in orientation, with just a small orifice for the steam to come out, like a smokestack, and they just stared into space. I spoke about the poetics of the ultrasonic mechanism as a vibrating interior shadow. I knew I was in the wrong place and at the wrong time, but I also knew that I was learning—learning that product development was not a creative field. Surely you could do a little styling (if the shaping fit the present vernacular), but there was little room for real design. What did they know about the rest of the world, what did they know about others likes and dislikes? Contradictory to their beliefs, I realized that design is not calculative, it is not a service profession to just answer to clients needs or consumers needs. It is not a profession that is based on market studies, stratas, marketed groups and tribes, focus groups, predictability of sales, solving problems (we have solved all the problems), meeting certain 'market' criteria, metonyms, but instead, a profession of a shaper new cultures, shifting human paradigms, contradicting the familiar, and proposing new object protocols - creating an exciting world, an experiential world, a poetic world. Design is music. Writing a song that can affect millions, that can inspire millions, that can reach the deeper spiritual side of our soul. It is a profession that should bring new experiences: greater pleasures and higher values, which will elevate and enrich our material world.

Anything I design today will really have an impact three years from now. Therefore I should project into the future; I should not look at the marketplace but examine changing trends, changing attitudes, new paradigms.

I remember the school of social responsibility, of humanization, of creating things for people. The true radical work in the world, the projects, artifacts, concepts, that

bow bag, Issey Miyake, Japan, 1997 extruded polypropylene sheet, large and small

really shaped our world, are mostly personal and somewhat stubborn visions of a few artists that saw the world unlike the average being. They saw a New World; they saw a new possibility, an alternative to the world, which we created.

Artists are perceptive, inquisitive, hyper-aware of their surroundings, so they see messages, ideas, signs, issues, opportunities that many others don't see. They see details. They see visual nuances. Artists exist in every profession. They are the few that are perpetually in search of, and highly passionate (if not completely obsessed sometimes to the detriment of others) of creating something original—a doctor finding a new form of medicine, a cure, or an alternative to the applied and dogma. I always felt that designers should learn everything about their profession, know it extremely well, dive into the deep end, so to speak, until their knowledge is saturated; then they have to forget everything. This catharsis, this rubric, is the cleansing process, the road to complete autonomy of thought so that one can create freely and change behaviors, change our human conditioning, our evanescent public memory, and change the world.

Post-industrial design is a profession that will engage the immaterial, the dematerialization of the object. We will eventually reach a state where as designers we will have fewer physical objects to design. The argument of post-industrial design is that objects are becoming more technological, more complex, and therefore require other experts to be part of the materialization process. So if I design a chip to be implanted in an arm or an eye, or I develop e-money as a fingerprint, at some point there will be always the same issue, interface, interaction, navigation, and possibly some physical dock. If my fingerprint is my credit card, someone has to develop the interface. What do I put my finger on; what do I touch? Is it warm, cool, smooth, slippery; is it attached to something? Is there some feedback of whether my finger has that credit limit? Do I receive a receipt; do I see a visual or audio? Do I have to protect that print; is there a cool little sheaf that becomes a fashion item, a sheaf that can differentiate me from everyone else to support my need for individual expression?

Post-industrial design means bioengineers, scientists, behaviorists (although I consider that I am a behaviorist as a designer), doctors, geneticists, etc. But there is only one person that keeps a pulse on the public, on human life—the designer. The designer is an editor of culture, a

sense bottle design, 5S, Japan, 2001 treated injection-molded polymer

conductor of the production of goods, the mediator between the corporation, the company, and the audience. The designer has a phenomenological role to understand how our object landscape is engaged or disengaged, how things change our lives, shape our lives, and touch our lives. An average person touches five hundred objects a day. These objects range from the hyper-banal like a toothbrush to the less than one percent probability of touching something new. Post-industrial design will deal with all our senses, as Gianfranco Zaccai once said, "Design has primarily focused on the visual and the tactile, but we are now." The kinesthetic, the sensorium, the omniexperiential: the future will be made up of an orgy of experiences. The digital age has created a new hypersensitivity, a more exotic connection with our senses, and a kaleidoscope of stimuli, of information, of living, loving, and well-being.

blib concepts for Yahoo!, USA, 2000

concepts for Ronson, United Kingdom, 2000

david byrne — a blip, a blob,

Why do people design things? Why is there such a thing as design? What isn't designed? Why are some people chosen, sometimes self-appointed, as designers, and others, who also make things, not? Why isn't it enough for engineers to make thing things? Why not simply allow the engineering experts to put together the necessary parts for a cybergizmo, a home entertainment center, a means of transportation or some hi-tech protective clothing? Although they are often invisible, nameless, and anonymous, engineers "design" the frameworks, the support systems, of our lives—the highways, the Internet, the browsers, the operating systems, the genetic hybrids, and the man-made materials we wear. So why do we need another layer of hoity-toity estheticians mediating our lives? Telling us, in effect, that it's not enough for some clunky piece of gear to simply do its job, but that it must look cool as well. Engineers after all made the bridges, the radar towers, the circuit boards, the parking lots, and the superhighways—all amazing looking and seemingly without needing any design education what-

concept for a multi-directional compact disc alarm clock, P3, USA, 2000

a groove, and a curve

soever. In fact their work was held up by the modernists as a mere perfect design. Truly utilitarian. No frills. And that stuff, as is now commonly believed, is often as beautiful as any consciously designed object . . . and more honest, to many people, as the beauty of these things is not tacked on, it's a product of just doing its job.

Don't I already have enough people urging me to adopt their esthetic decisions as my own without a bunch of aesthetic experts joining in. This software program I'm typing this on tries repeatedly to tell me when it thinks I should capitalize a letter, when it thinks I need bold type, and when it thinks I should indent. I don't want to have my letters look like what some MicroSerf decided is right for me. I'll make up my own mind, thank you. I've got enough interference in my creative life without another set of jargon spouters joining in.

But maybe design doesn't really exist just to do the job and to do it well. Maybe doing the job is besides the point. Any well-engineered item can do that. Many times beautifully designed objects barely do the job, but still we choose them anyway. Are we crazy? Are we suicidal and masochistic? Maybe not.

Design speaks the language of innuendo, of smell, of love, of sex, of desire, of facial expressions and body attitude. It is the human interface. The interface to our unconscious. Like music or images, it uses its wiles to slip its charges past the guards of reason, logic, and common sense, who would normally refuse admittance, on the grounds that the utilitarian object is more practical. Designed things communicate these murky things in ways that are only partly understood by semioticians and cultural theorists . . . the rest is pure instinct and vibology. Designers work in this nebulous zone. Where a blip, a blob, a groove, or a curve can imply sex, or at least well being for the next fifteen minutes.

The major design current since the mid-nineties, as I see it, has been an emphasis on joy, exuberance, and optimism. What I see realized before me now is an image of the future as it was portrayed in the movies, books, and magazine articles of the sixties, finally here. The uniformlike clothes in bright colors, the weird gizmos in shapes inspired by the Jetsons, the curved edges, the candy colors, the impossible structures, and the talking watches are all here. TVs balanced on their own antennas, buildings that look like they fell apart, and ridiculously tiny things that talk to us. They, the hack science fiction writers, the art directors and

production designers of sci-fi movies, and the lousy cartoonists of Hanna Barbara from forty years ago, predicted it, and now we, in the present, have to live it.

Our present is a fulfillment of their image of the future. We're living in a retro-future, if such a thing is possible. We have become what they said we would be. And it looks great. (We tweaked it a little—we're sexier now.) The sad part is that our design imaginations seem to be limited by what was imagined forty years ago. That we're restricted to filling in the dots on someone else's coloring book. The incredible part is that what was once tacky and campy, like polyester matching outfits, is now, ever so slightly modified, the height of hip. Our most sophisticated high-tech machines look like preschool toys for the Jetsons. Our stereos, cars, and computers look like sci-fi comic versions of themselves. A slightly reworked leisure suit is actually a pretty cool idea. (If they've actually solved the pesky problem of the odor retention of manmade fabrics.) The bright colors, the flatness (no detailed patterns), the racing stripes, the curves, and the mutant materials all seem to say that we can do anything. We can have it all.

This is good. We've finally gotten past both the postmodernist mix and match and the modernism it reacted to. We've caught up to ourselves. We are wildly optimistic that everything will be better, in a couple of days, and we have the toys and clothing to prove it. Our bright orange tank tops, mauve Citicars and purple hand scanners turn stock analysts into the adolescents they still are inside. We can fix anything—diseases, education, and entertainment, with just a click, if not today then tomorrow. We can make hugely successful businesses out of nothing, out of a store that doesn't exist that makes nothing. It's so clean! The future is shiny and new just like it was supposed to be, none of that *Blade Runner, Star Wars,* Cyber Noir grit and grime. And we can live any way we want anywhere we please. Everything is possible. It's going to be very very good.

Blobs, the form that most of this design takes, are huge dollops of puppydog cuteness plopped into our living rooms and offices. They create a world where the landscape of squiggly, ergonomic, and organic shapes seems to imply that everything is alive: that our things are our friends, our pets, and our family. That these things might even be just as good as the flesh and blood friends, pets and coworkers they mimic, in a weird way. It could be seen as a slightly perverted return to a Pagan animistic worldview. A return to

emporio armani
flagship store concepts, New York, 2000

a point of view in which every rock, tree, and river harbors its own spirit and life force. The hills are alive, and so are our gizmos, our clothes, and our homes. If my TV is smart, then by extension maybe that rock in the yard is smart too. This world view arrives slightly perverted, because it's designers who made these things look like they possess spirit; it's not a quality of the things themselves, our hearts, or the Force. These animistic designs seduce us into believing that a Silicon Graphics machine, a Palm Pilot, or a car dashboard is a friendly device, when we all know they don't give a shit about you or me. We buy the metaphor with pleasure—who doesn't want to be seduced?

I admit to liking the fact that technology has allowed us, in some ways, to admit defeat. To see the world as a powerful living entity that technology can never master. The postindustrial age has brought us to a world view that is very much pre-industrial. The cyber world of interconnectedness and marvel has taken us full circle, to a belated realization that our world is indeed alive and that there are forces in the universe that play upon one another and on all of us as if we are the attendees in one vast nightclub—with the bass booming and the dark sexy shapes lurking in the shadows. A place to meet and be met. To do and be done. Club Universe. A hipster version of the Circle of Life, with a digitized funk soundtrack.

It might be that in compensation for having evolved ourselves into a state in which our social values are almost nonexistent, destroyed by the industrial age, we are now creating a new world of little creatures, who are just like us. Blank but fun. It's sexy and joyful world in a way that the aesthetic of the factory never was. It's a Dr. Seuss version of a factory. A factory of the imagination and spirit. A blobby squiggly factory that giggles when you touch it.

I know, however, that the dark side lurks, like the smiley faces on the Korean Police's riot shields, there's a flip side to all this. The bigger the front, the bigger the back, as they say. The more the surface reeks of cuteness, niceness, and well being, the more nastiness lies hidden just beneath it. The refrigerator that shops for you, that talks to you, that is making life so much easier, is actually your personal jailer. That global positioning system in your car, that cell phone that does everything isn't doing it just for you. It's doing it to you too.

You can count on it: the more something promises to be for our own good, the more we should be suspicious.

There are truncheons and tear gas right behind those smiley faces, and Mickey's corporate back up team doesn't win any medals for niceness either. Those blissed out blobs are holding knives. The more design, and just about everything else, focuses on our inevitable glorious future the more Columbines there will be. The more Eminems, Snoop Dogs, and Dr. Dres to counterbalance the euphoric boom. The utopian manifesto that is contemporary design is revealed to be a dystopia, the Soviet Union of Pókemon.

The space age baby curvy design just makes it all seem more harmless. The more we control the more we are controlled. The nicer we are the meaner we are. The more in touch we are the more we are touched. (I could get carried away here.)

But in spite of my own gut instincts and paranoia I want a happy ending. Despite the fact that I'm scared of advertising, that I'm mistrustful of good design, and I'm really scared of the lovely ladies that look down at me from billboards as I bike down the street I still enjoy them. They've got my number and they know it. And I know that they know it and I like that they know it. The rounded edges, the space age fabrics, and the three thousand dollars items that look like mere toys push my buttons too. I've grown suspicious of anything beautiful because it manipulates me. Sunsets included. But here's the thing. They're still beautiful. Most of these things are also so obviously fake, so obviously manufactured that their self-knowledge relaxes me. Most of the time I like the blobs, the blips, and the clever copy. It's entertaining, and it's who we are. It congratulates me for being so cool and I congratulate myself for getting it. So we both feel good. I know what they're doing to me, and they know that I know what they're doing to me, but it doesn't matter. I don't ever want it to stop.

» Karim è americano come è americana la Cadillac, il Greyhound,
» come è americano George Nelson,
» come non è americana la Mini Minor, la Fiat 500,
» come non è americano Jasper Morrison.
» Karim è lì, dentro questo mondo americano".
» Eugenio Perazza

dakis joannou apartment
Trump Tower, New York, 2000

cocoon concept for furniture, Totem, 2000 self-skinned injection foam

MORPHE SCAPE

- make a grid parting line
- colored glass
- colored glass
- colored glass
- colored glass
- Headrest Speaker
- colored glass
- small monitor
- Projector
- 6' monitor
- Monitor
- 20'
- stove top
- stool like
- colored glass
- white glossy
- 20'

- Leisure zone
- Solo Relax
- sleep
- 20'
- 20'

softscape
concept for living, SFMOMA, USA, 2000

An infinitely shifting undulating soft terrain as a proposal for the future habitat. The computer-generated Softscape is a morphed landscape, completely biomorphic, composed of rearrangeble forms that grow from the floor surface to provide diverse interior environment needs such as living, sitting, resting, playing, engaging, working, etc. This installation references the notion of prefabrication of architectural components or modular experiments of the 60s but is seamless and does not obviously communicate its modularity and is based on many components, not a singular repetitive module. The notion is a small abstract blobscape that suggest or alludes to an infinite reconfigurable system for personal configurations.

The soft interior landscape provides all the necessary postures and anthropometrics for a more pleasurable and comfortable life. Embedded in the Softscape is seamless technological components for heat/ cold/ air/ light/ music/ sound/ visuals/ telecommunications, infotainment, and anitonics, and audio/ visual screens, projection, and interface for this SMART space. Data and energy run through the space revealing jacks, infrared and slots for inserting media, etc. Technology plays a very important role although in an inconspicuous way as the concept is a statement for the seamless coexistence of technology and humans in the most primal of urban spaces, the house. The fragmented way which homes are designed (individual non-linked items in a rectangular space) is eliminated, replaced by a holistic anthropocentric approach. Elements are designed as modular units that fulfill from the most basic needs of resting socializing etc. to technology driven pleasures of our time. Hi-tech items are removed from their impersonal black boxes and placed inside our surroundings. Technology is our way of living and should be incorporated as any other aspect of our lives we are accustomed to. Denying technology is denying our present, our contemporary way of life, a belief in one's own capacity and possibility of self-being. Our behavior and social being is changing and this space addresses and questions these issues.

>> The resulting strongly felt changes in our perception, in our relationship with the world, and in our everyday behavior
>> attest to a birth of new esthetics. It is an aesthetics whose designated object lies beyond the visible, beyond the tangible,
>> in the zones of infraperception, alongside our modern awareness.
>> Fred Forest

blob table and stool, Sputnik, Japan, 2000 steel chrome legs with fiberglass top

packaging for L'eau d'Issey Pour Hommes Father's Day Kit, BPI Perfumes / Issey Miyake, France, 1999 rotationally molded PVC

soft sony

concept for clock radio, Sony, Japan, 1998

alessandro mendini beauty

Beauty is a sensation, hence subjective. Everyone has his own idea of what is beautiful. Over the years, I have treated design as communication. It can be strong and paradoxical, because when I design I try to pick out problematical elements, of which all my work is eventually a critical, social, or political demonstration. The method I use to seek what I find beautiful is now poetic, now religious, now ironic. And it transmits what I want to say each time. The word "beauty" nowadays is very difficult to use, but beauty can be attained whenever the design positively communicates its intention to be a work of art. I try to make my things demonstrate a spirit and energy that may induce people to meditate on themselves and the word. If they do, then I have achieved beauty.

I am fascinated by the idea of change. Generally, designers have in mind doing something certain and incisive, something that will never be changed; whereas I, after having done a design—which was topical while I was doing it—soon find it already dated and superseded. Often I don't even want to see it realized as its corresponding object. Because what I care about in things is mutation more than stability, and indeterminacy more than certainty.

I am attracted by the fact that my design changes continuously and is a provisional event, hardly connected to the static coldness of reality but rather to the ephemeral vibrations of the unknown. That is why I think of ornament as a free and infinitely iridescent thing, as in the eternal game of "decoration." As far as I am concerned, ornament prevails over design today. Decorations do not pollute; they vanish into thin air as fast as they appear, and in that brief moment we are morbidly attached to them. They supply energy even to the coldest structures of our everyday lives. To yield to a total decorativeness of the world means to enhance surface, the depth of the superficial. Furthermore, decoration is a mass exhibition. We are in a period when the world seems once again to engender the fantasy that the rational world has denied us.

Every new design is always only a redesign. All the form and colors of the cosmos belong to an endless flow, a dusty magma that makes bodies, clothes, objects, buildings, and surfaces look alike.

The essence of the designer's work lies not in the specific and disciplinary limits of design projects, but in the invention of a project for life, a project for rites, ceremonies, affections, and understanding, where design is seen as a medium of expression. The prime words to be adopted when talking about objects and spaces are "universe," "religion," "eternal." They are the selective narrow passage through which the difficult enigma not only of contemporaneity, but also of forms, can be resolved in a synthesized vision. Design, aside from its innumerable styles, is mind. It is the living sense of matter.

concept for compact disc player / boombox, P3 / Totem, USA, 2000

blob chair, Nienkamper, Canada, 1999 injection-upholstered polyurethane foam

Never be satisfied with your work.

blob chair, Magis, Italy, 1999 injection-molded polypropylene

blobject
chair, Sandra Gering Gallery, New York, 1999 automotive lacquer on fiberglass, limited edition of ten

wurseat wicker loveseat, IDEE, Japan, 1999

blobject special Edition for Trans>6, 1999 vinyl-dipped soft PVC

karim rashid — blobism

The world around us seems to be perpetually getting softer. Our objects are softer, our cars are rounder, our computers are blobier, and even our bodies are fatter. Fate may have us envisioned as a Marshall McCluhan sketch of a round spherical oval floating in space, with small arms and hands—a vision of a world where we maneuver and experience only through our minds. The digital age, the information society, the global village, and the leisure culture are all acronyms that symbolize a changing physical world where "soft" denotes our landscape. Soft is a metaphor for our forever-changing, ever-vast organic system. Maybe the increased interest in our aging population has something to do with this softening as well Universal design means design for children, handicapped, and the old, so what can address this common denominator more than the most blunt malleable landscape of objects to surround and address our everyday needs?

Is Soft a style? Is it an axiom of our new physical landscape? Or is it a desire to conquer in all mathematical probabilities, forms that could previously never be documented in any rational formulae? Are our objects a result of new computer-aided tools of morphing? I have been working with these Bézier Raster programs for awhile and I see that we are shaping a world inspired by these highly complex dimensional tools. Nurbs, splines, metaballs, and other bioshaping commands are fostering a more relaxed organic condition. There is a command in a software program called "metaball," where I can take any sacred geometry such as several plutonic forms—a cube, a sphere, a cylinder, and collage them together or metaball them into a liquid plastic biomorphic form that I can regulate—softer, globular, or tighter, and more defined.

I used a term "blobject" several years ago to descriptively name a couch I had designed with these tools. That term has become ubiquitous. In Bruce Sterling's "Return of the Blobject" in *Artbyte* (Mar. 2000), he states "The Blobject first swam into my ken at the High Ground Conference in 1999 "Presently at the DESIGN CULTURE NOW, The first design Triennial at the Cooper Hewitt Museum in New York a section of the show is dedicated to "Fluid." Steven Holt, a curator for industrial design in the show states in the catalogue, "We are in the closing years of the Blobject, a period that began in the eighties where everything from the Ford Taurus to the Sony Walkman to the Tylenol caplet was designed with curved contours and swoopy silhouettes."

Soft is not just relegated to form and shape but also refers to our new material landscape where tactile surfaces give us comfortable, engaging, physical experiences. Polymers, such as synthetic rubbers, santoprenes, evoprenes, polyolifens, silicones, translucencies, transparencies, all contribute to the new softness of our products. Multiple materials on a singular object by new technologies such as dual-durometer molding, co- and triple-injection enrich the

kase limited-edition deluxe hardcover, Universe Publishing, USA, 2000

Think extensively, not intensively.

interface with our bodies. We have heightened our experiences via touch. Materials can now flex, change, morph, shift color, cool and heat, etc. due to the Smart material movement. Smart materials are materials that communicate and give us feedback. From toothbrushes to color changing hotwheels, these new stimulating phenomena all play a role in our new "relaxed" environments.

This softening or Casualization of Shape, form, material and behavior, are definitely a movement—and a movement that is notably American. America is, to use a Victor Papanek term, "casually engineering" the rest of the world. Yes, America has created a kind of digital language of blobifying our world, physically and immaterially. This is not the first time America has literally shaped the world. The blobject movement is here thanks to a handful of designers such as myself who have taken a great interest in organic form and the technology that is affording us to morph, undulate, twist, torque, blend, and metaball our concepts. Also new production processes and methods are contributing to this New World language. The organic movement of the '40s and '50s grew out of California in furniture and architecture by Vladimir Kagan, Isamu Noguchi, Darrell Landrum, Charles Eames, Harry Bertoia, Kielser, and Zeisel, or in Europe with Carlo Mollino and others. They organically formed new spaces and objects. Objects were made imprecisely by hand and replicated in tools produced by hand so surfaces did not have the perfect articulations that our computer generated tool paths and paraballs have. Today we can produce precise complex geometries that can be digitally processed and produced ad infinitum. Now the landscape will flow. The only thing that prevents our architecture from becoming compound and organic is our antiquated methods of building construction. Today building is a reconfiguring of existing Cartesian modular components all based on a grid. Lack of a grid is analogous to the autonomy of hypertrophic experiences, of simultaneous, and of the complexity of accessible free information in our binary notation of bits of information in our digital age.

I have aggressively softened objects for our contemporary culture because soft means human, friendly, approachable, and comfortable. Soft is an extension of our bodies—tactile, flexible, playful, and engaging. Soft is not decorative or embellishment if it relates directly to the subject at hand—us, interfacing with things on a daily basis. The danger is that if "soft" becomes a style, then everything will be blobified just as Raymond Loewy fronted in his "streamlined" style of the '40s. Soft has its specific smart applications. Presently there is plethora of objects out on the market that contribute to the new softscape, which are completely logical that they be organic—speakers such as the Harmon Kardon I-subwoofer, the IMac, Prada shoes, Nike shoes, Chanel bags, Oakley sunglasses, inflatable objects, the Swatch telephone, Sony Walkmans, Philips answering machines, Nokia cell phones, G-Shock watches… .I could go on and

globject special edition for Trans>6, 1999
electro-luminescent sheet, soft polyurethane resin, and cables

As well as a visual softness, they incorporate use of new materials that create a numinous womb aesthetic–sensual, sexual, subliminal and ethereal. There is already a book released on *Blob Architecture*, a contemporary collection of projects that obviously take references from Eero Saarinen's TWA Terminal from 1956, and architects such as Le Corbusier, Oscar Niemeyer, Eduardo Torroja, Enrico Castiglioni, and other organic architecture structures of the '50s and '60s. Casualness and softness form our new "casual" aesthetic, less formal, more organic ways of living and being. Our aesthetic objects are taking on our casual constructs from sweatpants and running shoes, to paper plates and bagged airplane lunches, from self-serve to self-help, from internet dating, to casual Fridays (which has notably creeped into casual Thursdays, Wednesdays, etc.), from the Gap to J Crew, from flexible working hours to working at home in your bathrobe, from shopping at home to going to church on-line. Convenience and casualness are hand in hand.

Are we becoming symbiotically and symbolically our objects? Tufen Orel, a French sociologist, talks about a post-industrial society where our conditions will be more relaxed, less rigid, soft not hard, where our experiences will be more hypertextual and less linear. It is not a coincidence that the driving force behind the changing and ever-shifting global lifestyles is becoming more casual, more relaxed, softer, blobular, if you will. Blob Architecture may shape our environments; organic systems will change our paradigms, and Organomics (a term I coined for the study of ergonomics and organic form) may shape the objects with touch everyday. I have a great love for inspiring neoteric things and spaces. I believe that the new objects that shape our lives are transconceptual, multicultural hybrids, objects and spaces that can exist anywhere in different contexts, which are natural and synthetic, inspired through telecommunications, information, entertainment, and behavior. Our interior landscape can captivate the energy and phenomena of this contemporary universal softness of the digital age. The birth of new industrial processes, new materials, new design tools, and global markets are new organic systems. I feel new culture demands new forms, new spaces, new ways of living, material, and style. Denying technology is denying our present, our contemporary way of life, a belief in one's own capacity and possibility of self-being. Technology is our way of living and should be incorporated as any other aspect of our lives we are accustomed to. Our behavior and social being is changing, and Softscape addresses these issues.

If freedom was a form it would be a never ending undulating boundless biomorphic shape that is in perpetual motion. Form follows. Fluid.

Any copy of this book issued by the publisher as a paperback is sold
subject to the condition that it shall not by way of trade or otherwise
be lent, resold, hired out or otherwise circulated without the publisher's
prior consent in any form of binding or cover other than that in which
it is published and without a similar condition including these words
being imposed on a subsequent purchaser.

First published in the United Kingdom in 2001
by Thames & Hudson Ltd, 181A High Holborn, London WC1V 7QX

© 2001 Universe Publishing

All Rights Reserved. No part of this publication may be reproduced
or transmitted in any form or by any means, electronic or mechanical,
including photocopy, recording or any other information storage and
retrieval system, without prior permission in writing from the publisher.

British Library Cataloguing-in-Publication Data
A catalogue record for this book is available from the British Library

ISBN 0-500-28316-8

Printed and bound in Italy

I am undoubtedly forever grateful to my wife, Megan Lang, my family, and my friends. A special thanks to David Shearer, Gail Shultz, Yoshiko Ebihara, Teruo Kurosaki, Sandra Gering, Paul Rowan, Paola Antonelli, Tucker Veimesiter, Peter Barna, Bob Borden, Jim Weyhrauch, Hani Rashid, Core 77, Peter Stathis, Lenore Richards, Aaron Betsky, Jan Kuypers, Scott Gibson, Chee Pearlman, Susan Szenasy, and Hiroko Sueyoshi for their support in propelling my career. Of course I thank all my terrific clients over the last eight years and I thank the authors of the essays in this book. Your essays bring intellectual actualization to my life.

I am very grateful to my staff and especially Yujin Morisawa, whom has been with me for the last several years.

Thanks to all the people who have inspired me including Ettore Sottsass, Gaetano Pesce, Jean Baudrillard, Rodolfo Bonetto, Ron Arad, Philippe Starck, Luigi Colani, Joe Colombo, Charles Eames, and so many others, including musicians, painters, artists, philosophers, writers, too many to list.

Very special thanks to Juliette Cezzar, Jason Miller, Ilan Rubin, the Rizzoli staff, and my staff for all the hard work to realize and manifest this book.

Thanks to all the people who buy and experience the objects I design.

And, lastly, thank god for the closing of the twentieth century. Now it is time to start fresh and begin a new chapter in our lives.

Contributors

Paola Antonelli
Curator, Architecture and Design, The Museum of Modern Art, NYC

Aaron Betsky
Curator of Architecture, Design, and Digital Projects, San Francisco Museum of Modern Art

Gilda Bojardi
Editor of INTERNI

David Byrne
Musician, NYC

Jeffrey Deitch
Gallerist, NYC

Toyo Ito
Architect, Tokyo, Japan

Teruo Kurosake
Owner of Idee, Japan

Ross Lovegrove
Industrial Designer, London, England

Alessandro Mendini
Architect and Designer, Milan, Italy

Eugenio Perazza
Owner of Magis, Italy

Kelly Rude
Design Critic, Canada

David Shearer
Owner of Totem, NYC

Photographers

Albion Associates Inc.: 56, 86, 100
Ron Amstutz: 41, 64 (installation), 96, 97
Pascal Aulagner and Syvère Azoulai: 197 (large image)
Chris Barnes: 46 (small chaise), 64 (Zoom), 196 (Umbra), 200, 201 (all)
David Bashaw: 20 (bowties), 22, 23 (all), 24 (all), 25 (all)
Blue Fish Studio: 36, 165
Antoine Bootz: 38 (main image), 39 (main image), 46 (two large images), 52, 53, 107
Fabrice Bouquet: 203, 209
Evan Dion: 60, 61, 62, 63, 240
Jim Dow: 192
Carlos Emilio: 81, 158,
Colin Faulkner: 164 (hat), 196 (hat)
Laurent Petit Foreix: 197 (small image)
Jurgen Frank: 98, 99, 116, 118, 163
Lynton Gardiner: 180, 181, 182, 183, 185
Doug Hall: 12 (all), 13 (lamps), 18 (lamp), 74 (all); 75 (all), 93 (triaxial), 186, 207, 208 (large image)
Francis Hammond: 37, 168
Matt Hranek: back cover
Yoshiharu Kondo: 30, 31, 34, 40, 42, 43, 48, 49, 50, 51, 54, 70, 71, 92, 101, 102, 103, 104, 108, 109, 110, 166, 170, 191, 215, 236, 244
Yoshiharu Kondo/Idee: 39, 93, 164
Steven Krause: 120, 232 (all), 233
Leonardo: 176, 177, 178, 179
Peter Medilek: 204, 205
Raymond Meier: 161
Jason Miller: 72, 121 (all)
Eva Mueller: 2, 162
David Nufer: 14 (frames), 15, 181 (Nambé)
Ann Laure Oberson: 5, 136, 137
Laurent Parrault: 67,
Dick Patrick: 18 (vase), 19, 21
Xavier Reboud: 237
Ilan Rubin: front cover, 6, 8, 14 (clock), 16, 17, 28, 29, 38 (small planar chair), 58, 68 (all), 69, 106, 112, 113, 114, 124, 148, 150, 160, 188, 189, 190, 193, 194, 195, 210, 242, 243, 249
F. Ruegg: 245, 247
David Shearer: 145
Ola Sirant: 73
Studio Tolle: 155

Other credits:

Page 27: Flume and Ellipsis vases co-designed by Karim Rashid and Leslie Horowitz
Pages 74—75: Mailboxes designed with KAN Industrial Designers